STUMBLING TOWARDS
VICTORY

✈ THE FINAL YEAR OF THE GREAT WAR ✈

WIRELESS PRESS.

Army Form W. 3395.
(In pads of 50.)

RECEIVED FROM B Y B

STATION Wireless Press

BY J Mankin

G. H. Q.

Date 11th Nov 1918

Time 11.15 hm

The following message from H.M the King is communicated. English

Now that the last and most formidable of our enemies have acknowledged the triumph of the allied armies on behalf of (jammed) I wish to express my praise and thankfulness to the Officers men and women of the Royal Navy and Marines with their comrades of the fleet auxiliaries and Mercantile Marine who for more than four years have kept open the seas, protected our shores and given us safety. Ever since that fateful fourth of August 1914 have remained steadfast in my confidence that whether fortune frowned or smiled the Royal Navy would once more prove the sure shield of the British Empire in the hours of trial. Never in its history has the Royal Navy with Gods help done greater things for us nor better sustained its old glories and the chivalry of the seas. With full and grateful hearts the people of the British Empire salute the white the red and the blue ensigns and those who have given their lives for the flag. I am proud to have served in the Navy. I am prouder still to be its head on this memorable day. Ends 1120.

George R.

26288i.—Wt. 1754/P.671.—10,000 Pads.—2/18.—W. & S. Ltd.—(E. 2596.)—Forms/W.3395/4.

STUMBLING TOWARDS
VICTORY

✈ THE FINAL YEAR OF THE GREAT WAR ✈

EDITED BY MARTYN LAWRENCE

ALSO PUBLISHED BY ROYAL ARMOURIES

Arms and Armour of the First World War (2017)

Saving Lives: Sir Arthur Conan Doyle and the Campaign for Body Armour, 1914–18 (2017)

Archduke Franz Ferdinand and the Era of Assassination (2018)

ACKNOWLEDGEMENTS

Thanks are due to Adrian Parry for reading a first draft of the text, catching a number of errors and making several helpful suggestions. Any errors that remain are emphatically my own. To Geraldine Mead, for the superb design and layout. To Jacob Bishop, for customary kindness in the face of countless image requests. To Jonathan Ferguson, Lisa Traynor, Nick Hall, Tristan Langlois, Cynthia Miles and Dan Challacombe, who offered generous assistance with captions and text. To Joshua Lawrence, who asked 'why?' And to the incomparable Collections staff of the Royal Armouries, whose dedication to the ever-rolling caravan of history remains a constant inspiration.

Published by Royal Armouries Museum, Armouries Drive, Leeds LS10 1LT, United Kingdom

www.royalarmouries.org

ISBN 978 0 94809 287 9

Designed by Geraldine Mead

Printed by W&G Baird

10 9 8 7 6 5 4 3 2 1

A CIP record for this book is available from the British Library

For image licensing enquiries, visit royalarmouries.org/images

✈ Contents ✈

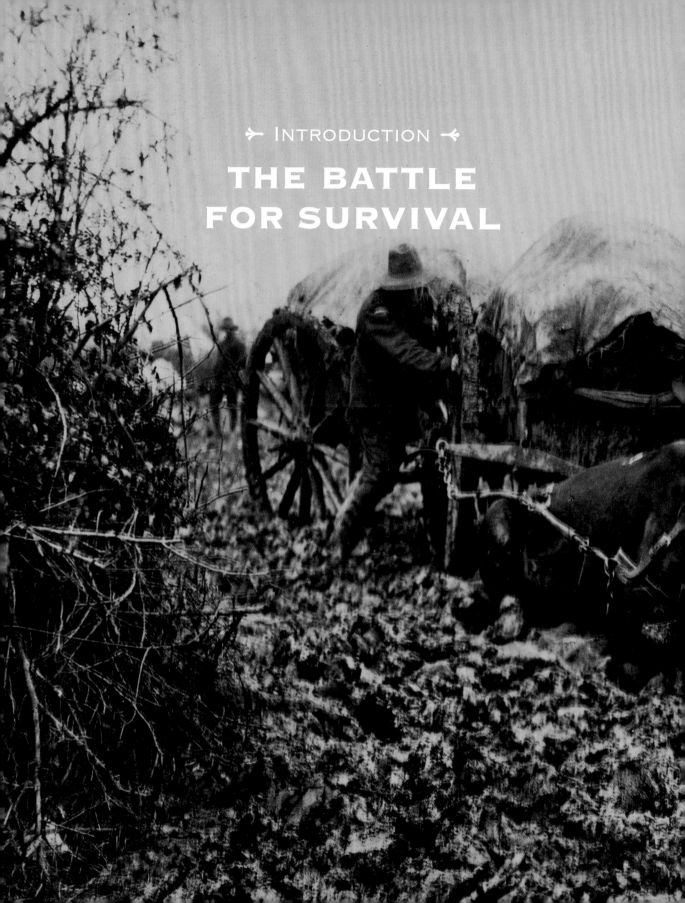

THE BATTLE
FOR SURVIVAL

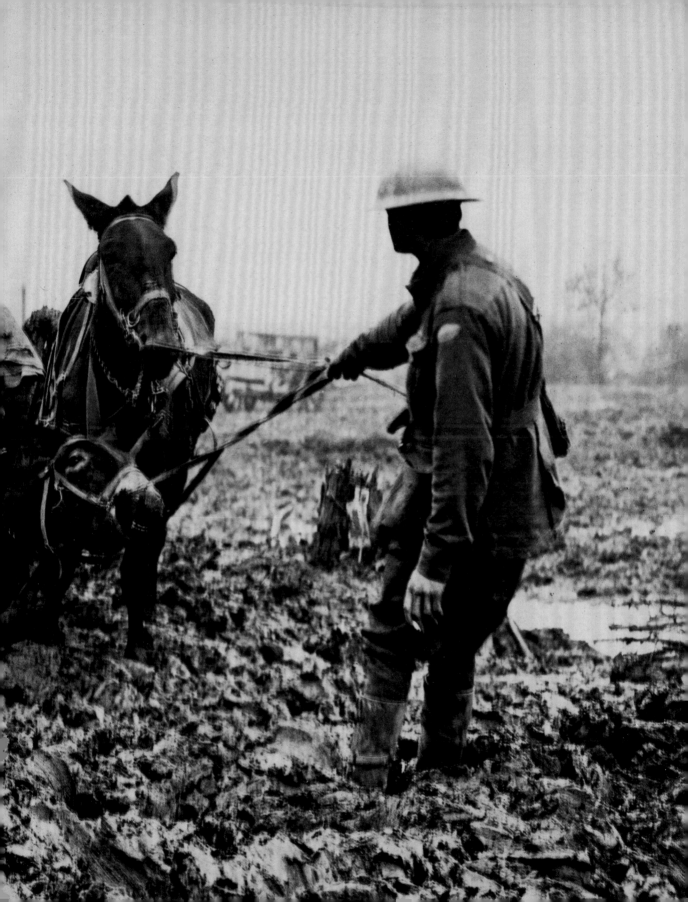

Opal fires in the Western sky
(For that which is written must ever be)
And a bullet comes droning, whining by
To the heart of a sentry close to me.

For some go early, and some go late
(A dying scream on the evening air)
And who is there that believes in Fate
As a soul goes out in the sunset flare?

On 11 November 1917, exactly one year before the armistice that ended the First World War, Field Marshal Paul von Hindenburg, Chief of the German General Staff, determined to launch an all-or-nothing assault in the west in 1918. November had seen not only a crushing defeat inflicted on Italian forces at Caporetto, but also the final conclusion of the Third Battle of Ypres with the Allied capture of Passchendaele Ridge. With some 275,000 British and Dominion casualties, the meagre territorial objectives of Third Ypres had been attained at a price out of all proportion to their value: Prime Minister David Lloyd George later described it as 'one of the greatest disasters of the war'. Victory for either side remained as elusive as ever.

As winter turned to spring, then, the Central Powers readied for the advance. Huddled in their trenches, Allied troops steeled themselves for another year of war. They had seen four years of indescribable bloodshed; four years of viscid mud and hollow sacrifice; four years of War Office telegrams arriving like whispers of death; four years of nerve-shredding, gut-wrenching stasis punctuated by episodes of terrible carnage – and until now, the trenches of Western Europe had remained as intractable as ever. In the skies and the oceans, from Ottoman palaces to Bavarian hunting lodges, in every theatre of conflict, the question was: who would break first?

The Eastern Front was already silent. Russia, incapable of fighting and destroyed by internal faction, had abandoned the war in November 1917. Tsar Nicholas II and his family had been squirrelled away in Tobolsk in the Urals, and were later to be shot and bayoneted to death in a cellar in Yekaterinburg. One-time combatants now met to hammer out peace terms, their base a grey, non-descript town on the Polish border. Despite huge resistance at home, Lenin and Trotsky instructed their Bolshevik delegates to sign the Treaty of Brest-Litovsk in March 1918.

But if the Germans finally had the war on one front they had long desired, it was to be a front now bolstered by vast numbers of American troops. President Woodrow Wilson had committed the United States to war the previous year when British signals intelligence confirmed that Germany intended to pursue a policy of unfettered submarine warfare against neutral and enemy alike. The decoded 'Zimmerman Note', in which the German Foreign Minister proposed an alliance with Mexico against the United States, did even more to turn American public opinion against Germany than had the torpedoing of the Cunard liner *Lusitania* in 1915, when more than 1,100 passengers and crew were drowned.

The US declaration of war injected an almost unlimited supply of troops into the Allied war effort and to some degree drowned out the growing feeling of war-weariness that swept across Britain and France in the winter of 1917-18. Yet such advantages did not appear immediately. Only a single American division was battle-ready: not for many months would sufficient men cross the Atlantic to make a difference to the balance of power. It was for this reason that Hindenburg and his staff hatched their plans. The 1918 spring offensive was intended to leave the French with no

alternative but to sue for peace, and to force the British Expeditionary Force back across the Channel. After four years in the field, Germany too was seeking respite.

In military terms, much has been written about the turning of the tide in 1918, the collapse of the German war effort and the eventual climax of the war. Even more is said of the armistice and the shortcomings of the peace process. The wider issues have similarly seen renewed interest due to the First World War centenary events: the struggle for morale on the home front, the psychological trauma caused by sustained exposure to fighting, the impact upon family life, and the technological advances in weaponry and machinery. Much of the recent work has also been focused on telling the individual stories of the millions who fought and died.

This book contains a series of photographs, many previously unpublished, from the Royal Armouries' archives. As the national museum of arms and armour and and heir to one of the oldest deliberately-created visitor attractions in the country, the Royal Armouries brings a unique perspective to studies of the Great War. The photographs featured here were all taken in the final twelve months of the war, as the Allies stumbled towards a victory that redrew the map of Europe but left many questions unanswered. The images underline the breadth of the conflict, from the broken ground and shattered trees to the men and women whose contributions form the basis for modern memorial. Primarily focused on the Western Front, the supporting text enlarges upon the themes found in the photographs and provides an underpinning narrative for the book.

The war of 1914-18 brought down empires, shredded the social order and upended lives from the poles to the equator. It banished the late-nineteenth century rose-tinted optimism that war on such an unconscionable scale could never happen, and the more pragmatic assumption that it could never be sustained economically. Offered here are visual memories of a bittersweet victory, unprecedented upheaval, and the final months of a global conflagration that was nothing less than an armageddon for the ages.

PREVIOUS PAGE

As the final twelve months of the war began, the British carried the exhausting memory of five months in the sodden wilderness of Passchendaele. Fought on a clay coastal plain with a high water table, the Third Battle of Ypres resulted in trifling territorial gains at an enormous cost to life. Double the average rainfall fell in August and early shellfire swiftly destroyed the drainage systems: consequently, artillery could not advance and supply lines had to contend with deep mud as the battlefield became a desolate quagmire. Here, a mule team is trying to get through the mud on a farm track near Potijze, in the Ypres Salient.

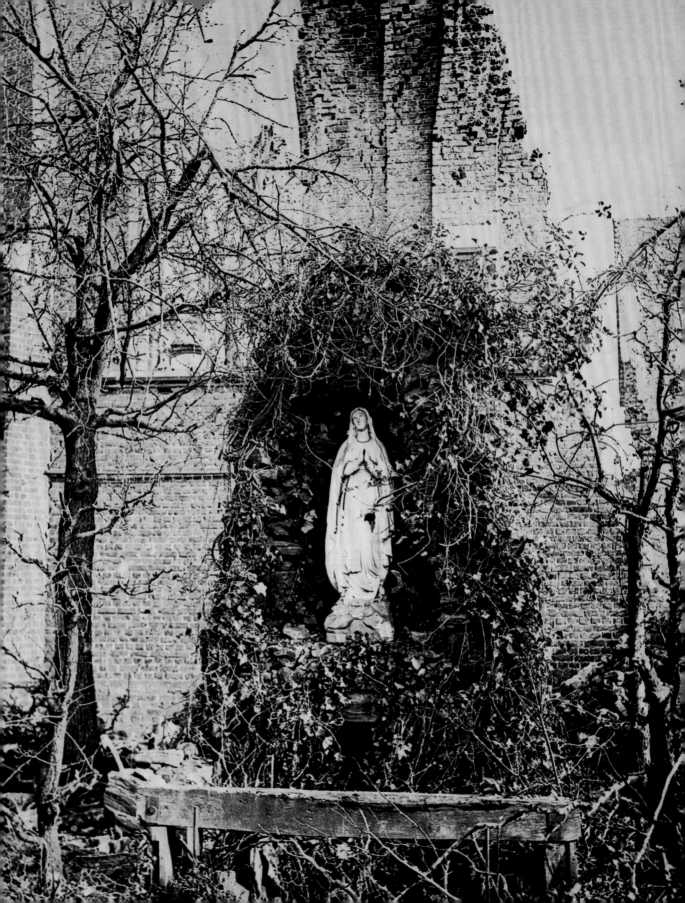

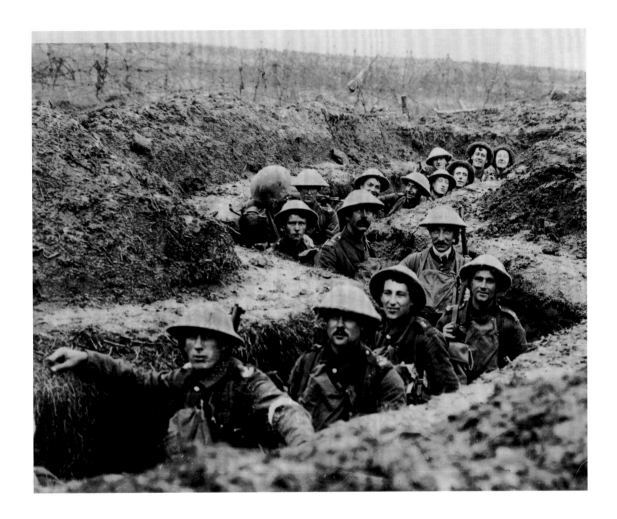

◄ **View of a shrine near a demolished church at Ypres, November 1917.** Though the surrounding buildings were almost obliterated, this shrine, remarkably enough, was not damaged. Third Ypres became one of the defining conflicts of the First World War. It claimed half a million casualties as Allied troops tried to push the Germans back from the coast, where their submarine bases threatened Britain's supply lines and the American reinforcements arriving by ship.

▲ **Men of the 11th Battalion, Royal Inniskilling Fusiliers, in a captured German communications trench near Havrincourt during the First Battle of Cambrai, 20 November 1917.** The assault on Cambrai was an attempt to mete out punishment on the Germans over ground that, unlike the mud-soaked Ypres Salient, actually suited tanks. Casualties at Cambrai totalled more than 40,000 on each side, but both armies made progress with new tactics (particularly artillery and storm troops) that in 1918 would point a way out of the deadlock.

✈ CHAPTER ONE ✈

WITH OUR BACKS
TO THE WALL

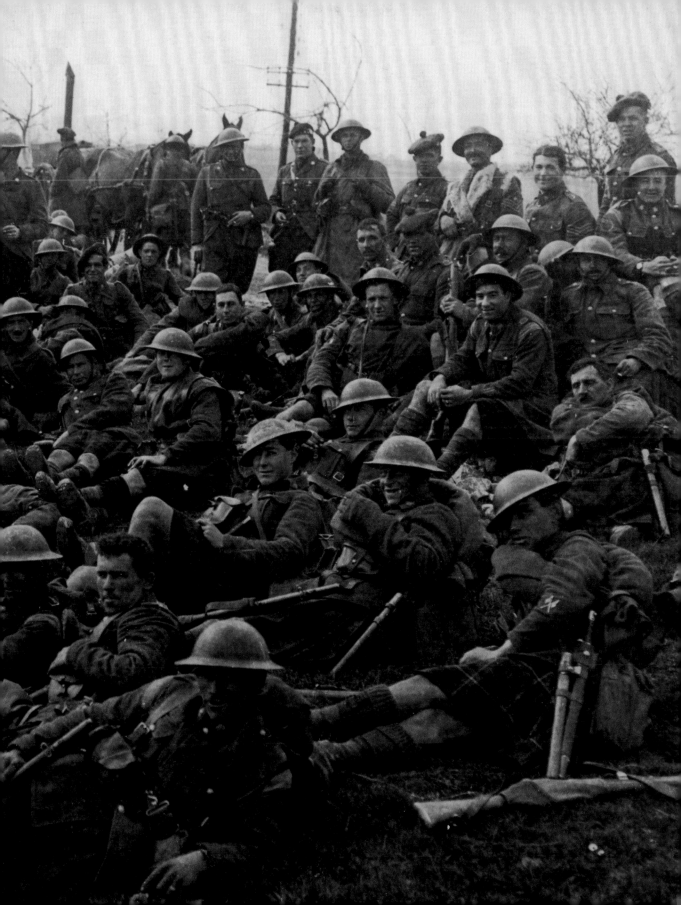

Early in the morning of 21 March 1918, General Erich von Ludendorff – thick-set, moustachioed, power-hungry – launched Germany's last great onslaught of the war. With Russia out of the fighting and the Eastern Front clear, Operation Michael was the first phase of a move designed to drive the British from the Somme and the French from the Aisne, long before the Americans could train sufficient troops to alter the outcome. The site was chosen with the goal of collapsing the British front and driving a wedge between the Allied armies at the point where they came together. Each, it was assumed, would focus on their own imperatives: the British would fall back to protect the Channel ports, whilst the French would safeguard Paris. Ludendorff funnelled his most effective troops into spearhead units called storm troops. In tactics that anticipated the Nazi *blitzkrieg* of 1940, these troops were ordered not to advance in linear fashion but to penetrate deep into British defences wherever the opportunity arose. Follow-up units would mop up any lingering resistance.

The Allies knew the attack was coming, but could not agree where it would take place. In the early months of 1918, British newspapers published dispatches from war correspondents that described the enemy's new gas weapons and the news that German tanks had been seen close to operational battlefields, but no one predicted the scale of the hurricane that would ensue. Both British and French commanders were forced into considerable compromises. They arranged their defences so as to protect sites that were strategically important to them – Haig, for example, reasoned that he could afford to give ground in the south providing the route to the Channel ports was secure – but, short of reinforcements and adequate preparation time, a number of difficult decisions had to be made. The British, particularly the Fifth Army under

General Gough, were also switching doctrines from 'attack orientation' to 'defence orientation' in efforts to emulate German use of defence-in-depth on the Hindenburg Line and at Third Ypres. A strategic misunderstanding resulted in the overall front line being too thinly held to neutralise the expected threat, whilst at the same time being too densely held to operate defence-in-depth effectively. This combination of factors brought dramatic consequences.

Described by Churchill as 'the greatest onslaught in the history of the world', Operation Michael was a short period of incredible ferocity. In just three days, the Germans captured Bapaume and Noyon, driving a wedge between the two Allied armies and threatening the vital railhead at Amiens. By 25 March, as many as 45,000 British and French soldiers had been taken prisoner, creating a crisis in the British High Command; two days later, the French were driven from Montdidier, a mere fifty miles from Paris. In barely a week, the Germans advanced forty miles on a fifty-mile front: a feat without parallel since 1914. Suddenly it seemed that the Allies would blow away like chaff before the wind.

Only a fingertip response diverted the German offensive push and saved Amiens. With politicians baying for his blood, General Gough was relieved of responsibility and French Marshal Foch – a man with a genius for instilling trust in his subordinates – was later appointed commander of all Allied forces on the Western Front. Yet still the Germans kept coming, with the British worryingly short of men. March and April were months of continual crisis. In Flanders, the agonising decision was made to fall back from Passchendaele Ridge, which had been won at such heroic cost the previous autumn; what effect this had on those who had survived those atrocious months of

shelling and strafing can scarcely be imagined. On 9 April, conscription was extended to Ireland – a move previously resisted to avoid stoking the fires of Irish nationalism. On 11 April, Haig issued his famous Special Order of the Day:

There is no course open to us but to fight it out. Every position must be held to the last man: there must be no retirement. With our backs to the wall and believing in the justice of our cause, every one of us must fight to the end.

The order was published in the press on 13 April, a stark warning to those at home that the army was in dire straits. 'Do not be hypnotised by the map', cautioned the *Daily Express* in an attempt to explain the greater troop movements (and in particular the loss of territory at Ypres) to a nervous public.

But the German troops too were approaching exhaustion, the tactic of using storm troops beginning to backfire as headline-grabbing gains foundered for the lack of a more coherent strategy. Time and again through April and May, no firm foothold could be found after the immediate shock of the advance. A lack of mechanised transport meant that the storm troops outran their logistical support, and the

follow-up units were deprived of experienced leaders who had been drafted into the leading groups. Ludendorff switched his attention to Paris, but despite getting within forty miles of the capital, was halted by the appearance of Americans on the Marne. Bloodied but unbowed, the Allies regrouped. With numbers against him, Ludendorff's demand for speed deprived his exhausted armies of rest, whilst his campaigns galvanised the Allies into a counter-response.

From March to July 1918, Germany captured more territory in four months than the Allies had managed in three years and inflicted around 900,000 British and French casualties. However, none of the ground was of any real importance, and Germany's own manpower reserves could not cope with the loss of around one million men. The result was that Ludendorff, consumed by hubris, had to hold many more miles of front with far fewer troops, and all in the knowledge that every troop carrier that crossed the Atlantic brought more American troops. Increasingly erratic, he refused to acknowledge that all hopes of military victory had gone, believing instead that by fighting on he could persuade the Allies to seek a peace settlement on terms favourable to Germany. As it turned out, only a political solution remained; the realisation would not dawn until it was too late.

PREVIOUS PAGE
Men of the South African Scottish Brigade resting by the roadside after seeing action at Dernancourt, 31 March 1918. The troops are wearing 1914 Pattern leather equipment. At the beginning of the war, production of 1908 Pattern webbing couldn't keep up with demand as the UK did not have many webbing manufacturers. However, it had many leatherworkers in a range of industries and so the Pattern 1914 was introduced. It was not particularly popular: regardless of the good quality of the leather, it was no match for conditions in the trenches.

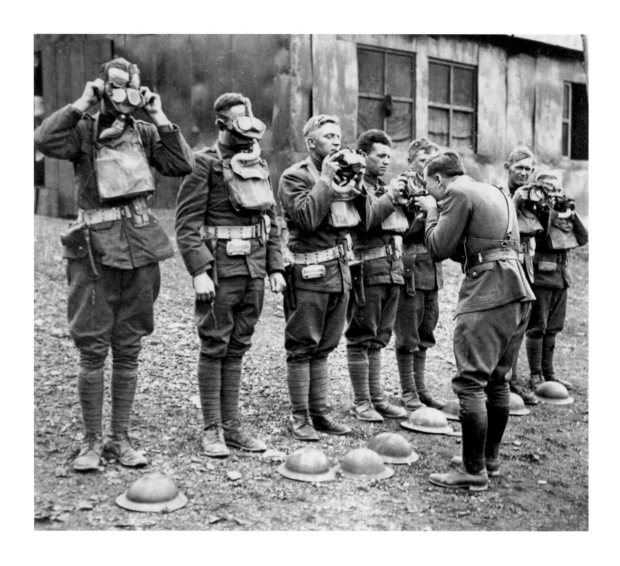

New American troops learning to use gas masks. The Germans were the first to use poison gas in an effort to reduce stalemate in the trenches, and it became one of the war crimes levelled at them during the Versailles peace conference. Approximately 125,000 tons of gas were used between 1915 and 1918, causing half a million casualties on the Western Front alone (25,000 of which were fatalities). Chemical warfare was one of the defining horrors of the war. American troops were particularly susceptible to mustard gas attacks in their early engagements, due to lack of familiarity with its dangers.

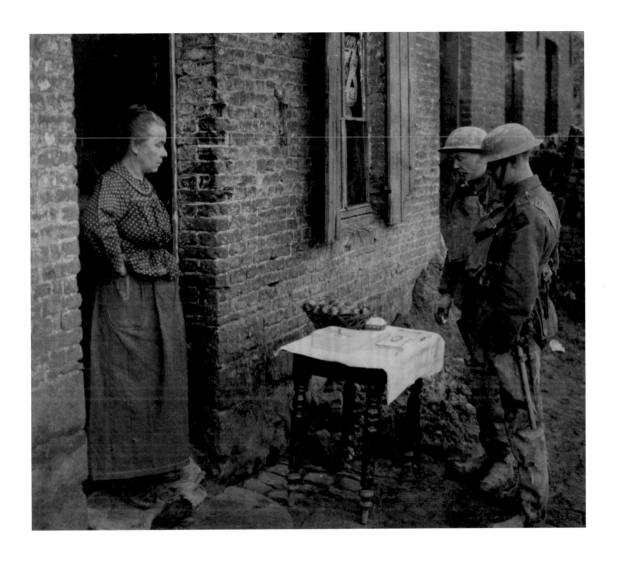

**Two men of the 5th Battalion, Manchester Regiment buying supplies from
a woman living near the front lines, January/February 1918.** Both men
are wearing trench waders, issued from regimental stores to units close to the
front line, rather than the standard trousers and puttees. No one in the exchange
appeared particularly impressed with what is for sale: the men may have been
hoping for Bass Pale Ale, advertised in the window to the rear.

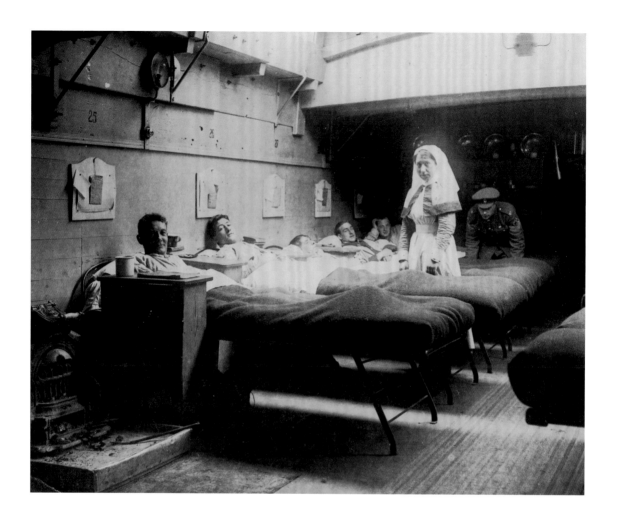

A QAIMNS (Queen Alexandra's Imperial Military Nursing Service) nurse stands among wounded soldiers lying down in their beds on a Red Cross barge on a French canal, possibly January 1918. In 1914 there were fewer than 300 QAIMNS nurses due to the strict rules on joining: personnel had to be aged 25 or over, well-educated and with impeccable social standing. As the number of casualties mounted, the qualifications were relaxed, and by 1918, there were over 10,000 regular and reserve nurses serving France, India, East Africa, Italy, Palestine, Egypt, Mesopotamia, Salonika and Russia. They worked in field hospitals, aboard ambulance trains, hospital ships and barges and in casualty clearing stations.

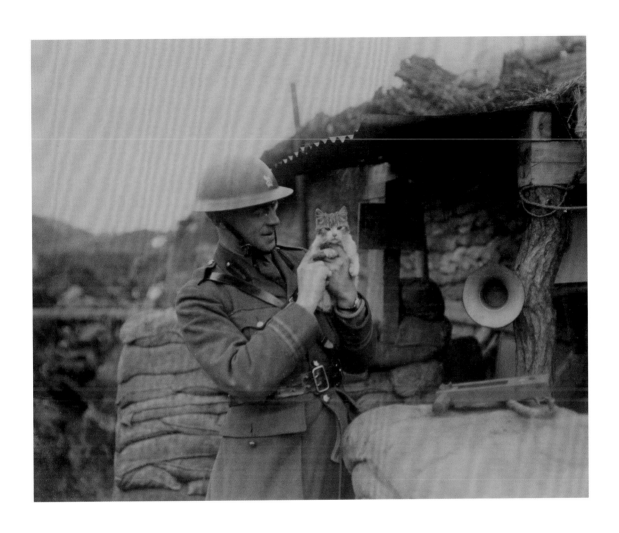

A staff officer of the 36th Division plays with a kitten outside his dug-out.
Many soldiers had pets in and near the front line trenches. Small dogs and cats
were most common, and they helped soldiers normalise the harsh world of combat.
Enemy pets were sometimes adopted after a battle, renamed, and became part of
the soldiers' community.

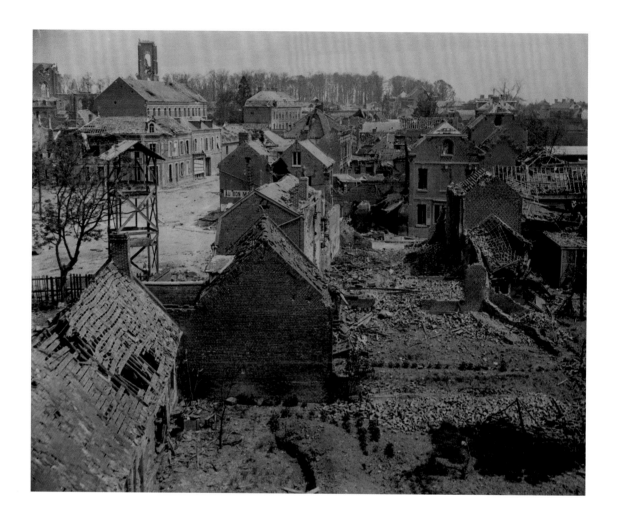

▲ The ruins of Villers-Bretonneux, 15 miles east of Amiens, photographed in April 1918. At the height of the German spring offensive, a major assault was launched on Villers-Bretonneux on 24 April. It was the eve of Anzac Day, when three years earlier, the sacrifice of Australian soldiers in the Dardanelles had indelibly entered the public consciousness. That night, two Australian brigades, 3000-strong, counter-attacked in a pincer movement, yelling as they charged under machine-gun fire. By morning, the Germans were in full retreat.

▶ The ruined church of Villers-Bretonneux after the Australian counter-punch. Had the Germans succeeded in their attack on 24 April, the vital railhead at Amiens would have been overrun, and the way to the Channel Ports laid bare. The year 1918 claimed 12,000 Australian lives on the Western Front, and around 60,000 Australians died in the war overall. In 1938, a hill overlooking Villers-Bretonneux was selected as the site of the Australian National Memorial.

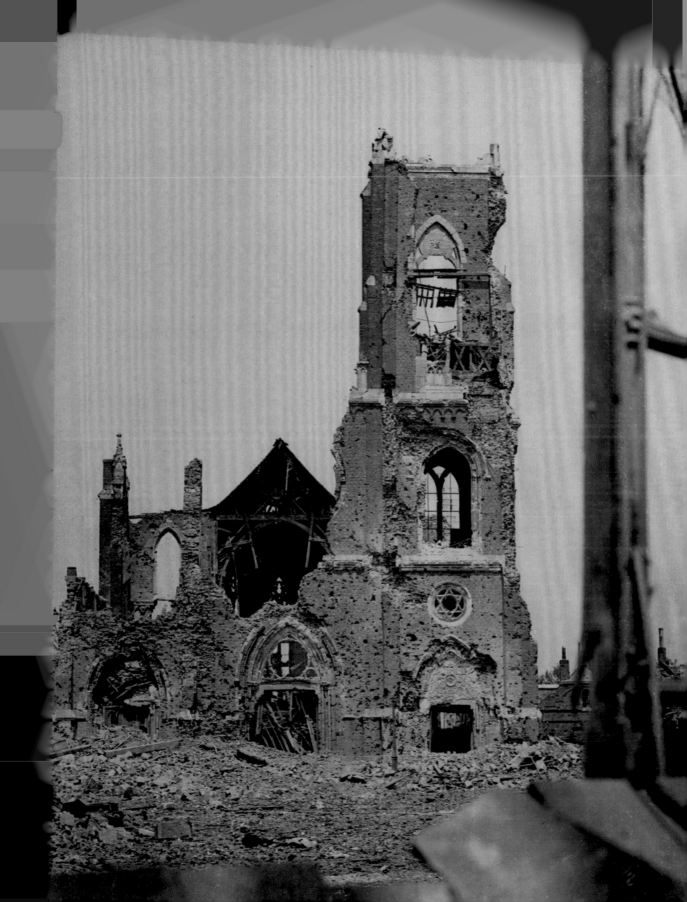

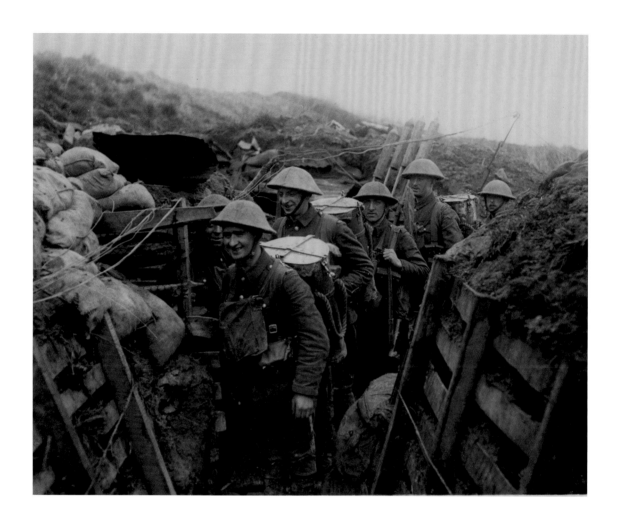

Carrying party of the 1/7th King's Liverpool Regiment, 156th Brigade,
55th Division bringing up rations through a communications trench to the
men in the La Bassée Canal Sector, 15 March 1918. Soldiers carried water
and 'iron rations' as part of their basic equipment, but this was for emergencies,
not day-to-day consumption. The British Army did its best to feed soldiers
two square meals per day, but fatigue parties were regularly sent back, often a
considerable distance, to where battalion field kitchens were producing vats of,
almost unvaryingly, stew.

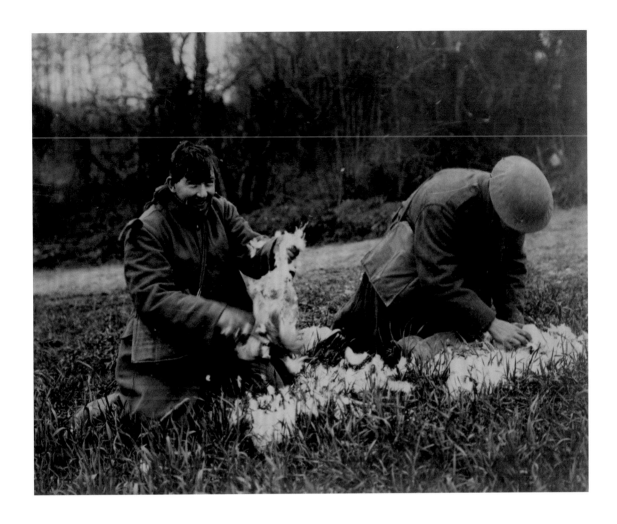

Australian soldiers plucking chickens. At the beginning of the war, soldiers received just over one pound of meat, the same amount in bread, and eight ounces of vegetables each day. As the war ground on, fresh meat and poultry was increasingly hard to come by; even when available, a hot meal at the front was a rare luxury.

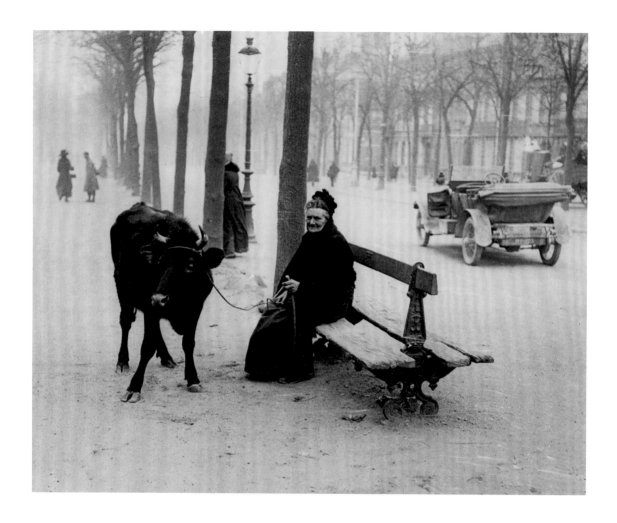

An elderly woman who fled the war zone with her cow, sitting on a bench
in Amiens, 28 March 1918. Civilians, no less than military personnel, suffered
major displacement during the First World War, and the post-conflict ramifications
were considerable. In both occupied France and the area close to the front,
requisition of supplies and food created wretched living conditions among
civilians: in some areas of northeast France the mortality rate more than doubled.

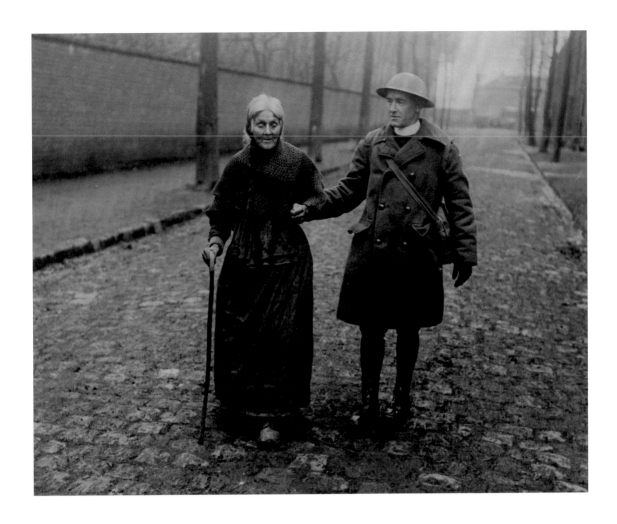

An infirm refugee from one of the villages on the Western Front being assisted by a British chaplain, May 1918. Chaplains' duties in the pre-war army were focused on the demands of garrison life in Britain, Ireland and the colonies. They were an integral part of Edwardian armies but were few in number, with no more than 120 commissioned chaplains serving an army of almost a quarter of a million officers and men. The advent of war had a profound impact on the Army Chaplains' Department: by November 1918 more than 5,000 new commissions had been granted to clergymen from a variety of denominations. More than 150 chaplains lost their lives during the course of the war.

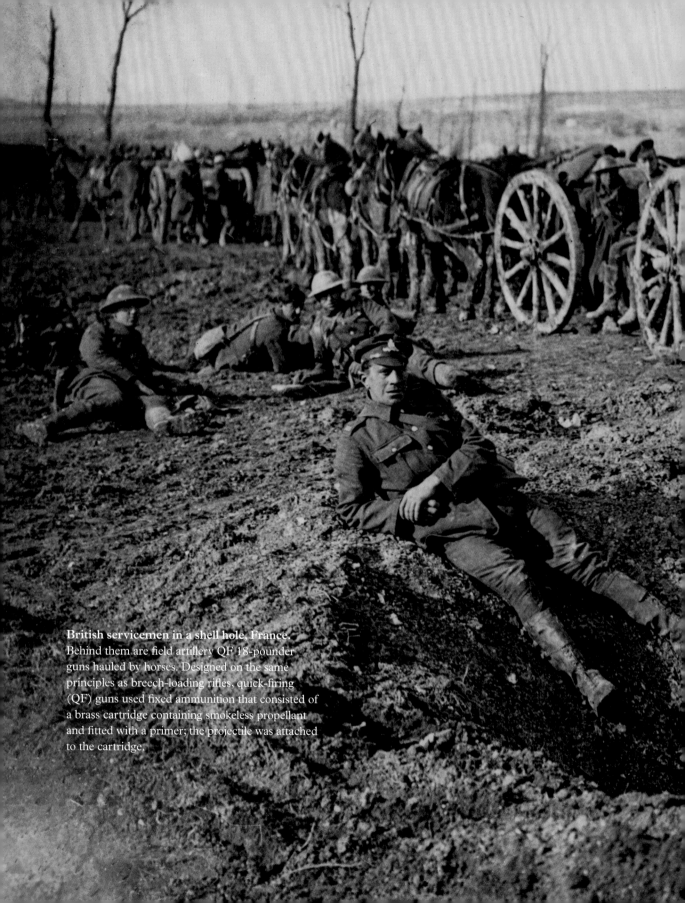

British servicemen in a shell hole, France. Behind them are field artillery QF 18-pounder guns hauled by horses. Designed on the same principles as breech-loading rifles, quick-firing (QF) guns used fixed ammunition that consisted of a brass cartridge containing smokeless propellant and fitted with a primer; the projectile was attached to the cartridge.

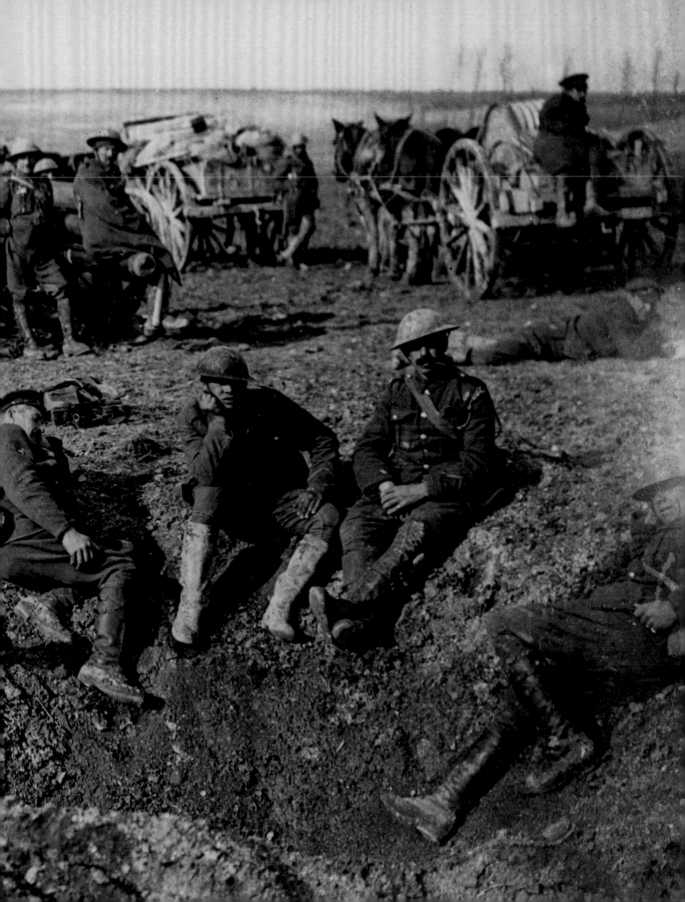

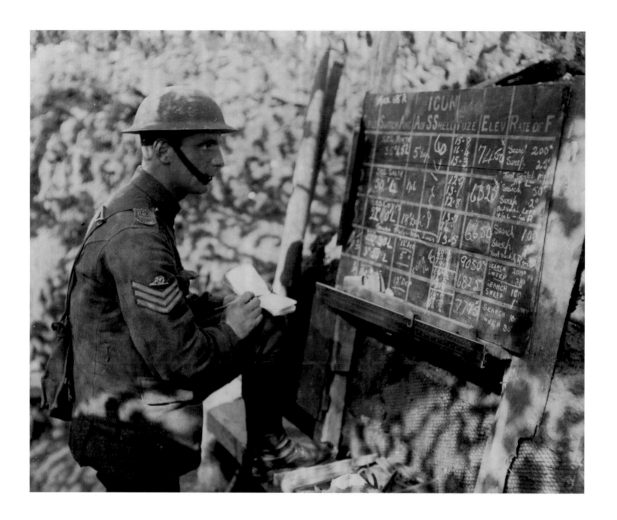

A Royal Garrison Artillery sergeant copying down instructions for SOS lines near Monchy-le-Preux (five miles from Arras), shortly before the start of Operation Michael in March 1918. The quantity of information on the chalk board is an indication of the technological advances made by artillery during the war. Weather information and individual wear on the gun itself was also taken into account.

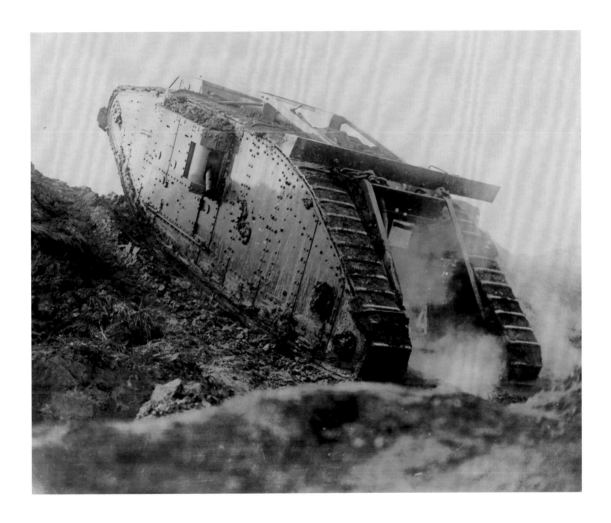

A British Mark IV tank. Nearly 460 Mark IVs were used during the First Battle of Cambrai in November 1917, showing that a large concentration of tanks could quickly overcome even the most sophisticated trench systems. They had a speed of 3 mph and a crew of eight. The 'male' Mark IV tanks carried an armament of four Lewis machine guns and two Hotchkiss 6-pounder quick-firing naval guns, whereas the slightly more numerous 'females' carried six Lewis guns. In the key Allied victories on 18 July and 8 August, tanks were used to suppress machine guns and scatter defenders; the Germans had been slow to develop anti-tank technology.

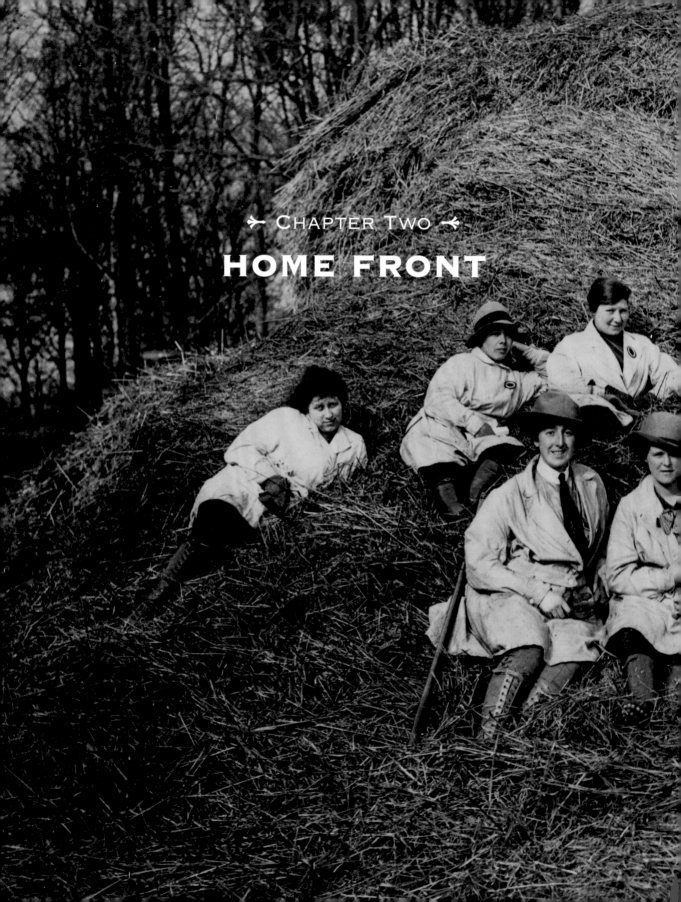

CHAPTER TWO

HOME FRONT

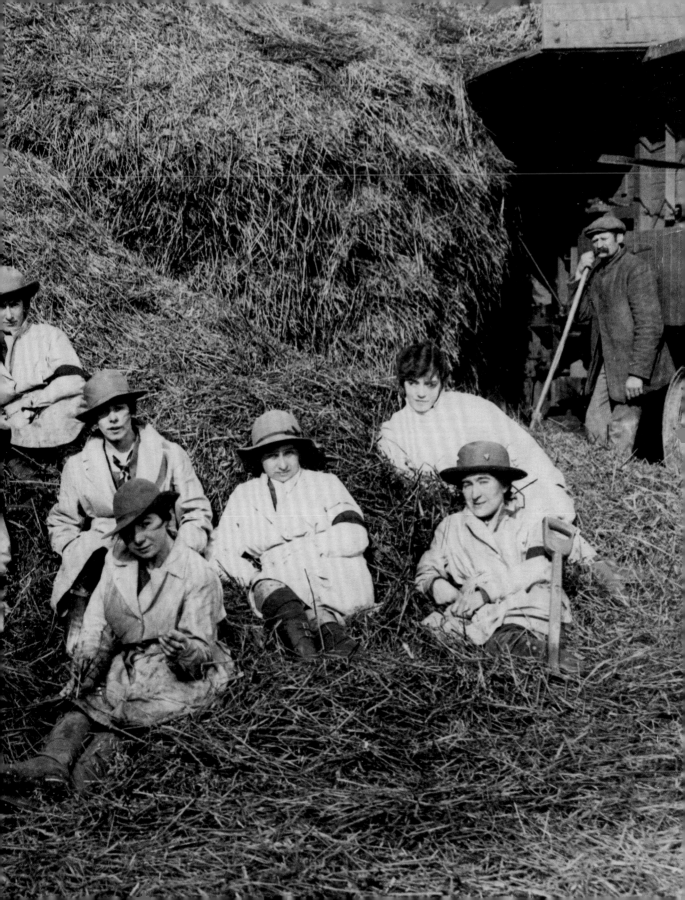

All the protagonists showed increasing signs of war-weariness by the end of 1917. Food shortages, high prices, poor housing and a series of strikes diluted the fierce patriotism that had been seen earlier in the war. In Berlin, supplies were drying up thanks to the vice-like grip of the Allied naval blockade. Worker shortages in France were so serious that around 350,000 troops were withdrawn from the front to work on the land, in mines, on the railways and in education. In Britain, the part played by women was a crucial factor in overcoming similar difficulties, and in both Allied countries victory would have been impossible without this. With so little movement at the front, the war was an endurance test to be decided as much by the willingness of the home front to bear the strain of the war effort as by the staying power of the armies.

In July 1914, 3.2 million British women were employed in industry, many of them in domestic service or textile work. Women's work before the war had been characterised by low wages, and the expectation that they would leave paid work upon marriage. Few challenged the prevailing idea that men should receive a family wage, since – unlike women – they were assumed to always have dependants. Widespread regional variations also existed, both in terms of the opportunities available and in the attitudes towards working wives.

Taking all forms of paid employment, more than 7.3 million British women were in work by July 1918, as conscription exacerbated labour shortages. There were a number of 'firsts', with women finding opportunities in the police force – or Women's Patrols, as they were first known – and the transport industry. Many encountered hostility from male workers who were nervous about competition for jobs, and found

themselves limited to performing certain tasks at severely reduced wages. Several of the 950,000 women in the British munitions industry struggled to reconcile their work as indirect 'takers of life' with their more traditional roles as homemakers and mothers. As it happened, munitions work was relatively well paid – especially for women previously employed in domestic service – but it was unpleasant and dangerous, and the working hours were long. Those working in close proximity to TNT or Amatol (an ammonium nitrate and TNT mixture) quickly became recognisable due to their faces taking on a yellow hue. The colour, which indicated toxic jaundice, soon became the chief characteristic of the shell fillers, with one worker at the Chilwell National Shell Filling Factory recalling that they were known as the 'Chilwell Canaries' because of their yellow hair.

Despite changing circumstances due to the war, women continued to be paid less and treated worse than men, and there remained many positions from which they were excluded altogether. Furthermore, in several situations it was impossible for women to retain their jobs when peace returned. In spite of the large increase in women's unionisation between 1914 and 1918, the increasing use of the marriage bar meant that the prospect of a long-term career was all but impossible. Even in burgeoning fields such as teaching and medicine, opportunities were only made available to women if they remained unmarried.

In the build-up to the formation of the Women's Army Auxiliary Corps (later the Queen Mary's Army Auxiliary Corps) in July 1917, followed by the Women's Royal Naval Service in November and the Women's Royal Air Force in April 1918, Haig expressed his reluctance to allow women to serve at the front in the same capacity as men. The first to be sent to France

were cooks and waitresses, later followed by medical personnel. One of these, the Australian doctor Phoebe Chapple, was awarded the Military Medal when the WAAC shelter she was inspecting came under German fire near Abbeville in May 1918. Aircrew dropped three bombs on the compound: two destroyed huts while a third exploded on a covered trench used by the women as a shelter. Eight women were killed outright and a ninth was mortally wounded. Disregarding her own safety, Chapple worked for hours tending to the dead and wounded, after which she was one of the first women to be awarded the Military Medal. Women did not hold commissions and were therefore ineligible to be considered for the Military Cross, a comparable award given to male officers.

Notwithstanding these challenges, many women revelled in the opportunities that emerged beyond domestic service. Following the formation of the Women's Land Army in March 1917, more than 23,000 women were recruited to work full time on the land. Recruitment posters, warning that Britain was on the verge of starvation, appeared across the country. Volunteers, if selected, had to be willing to go wherever in the country they were required, and were given free railway warrants to get there. Experienced women were put straight into paid work on farms, whilst inexperienced recruits first attended training centres or 'practice farms'. The majority worked in agriculture as milkers, carters, plough women and market gardeners whose main aim was to increase food production during the war. Others worked as foragers and timber cutters.

Even factory work offered greater freedoms and higher wages than available to women previously. All of this would herald a particularly far-reaching change in the last months of the war when the Representation of the People Act extended the vote to nearly nine million women. Scottish trade union leader Mary Macarthur believed that women's war work would make female suffrage unavoidable, but although the passage of the bill in February 1918 was a significant stepping stone, considerable inequality remained: many of those women who had toiled in war industries or in the Land Army were under thirty and thus remained ineligible. It was not until the Equal Franchise Act of 1928 that women attained the same voting rights as men.

PREVIOUS PAGE

The Women's Land Army (WLA), formed in 1917, marked the first time that a group of women came together in a national organisation for farm work. It was part of a broader effort to mobilise a domestic force of female workers, but was tasked specifically with replacing the male agricultural labourers enlisted or conscripted into Britain's armed forces. Its principle aim was to bring urban women into the countryside, although placing women on British farms not only risked local prejudices but also came up against regional variations in farming practices.

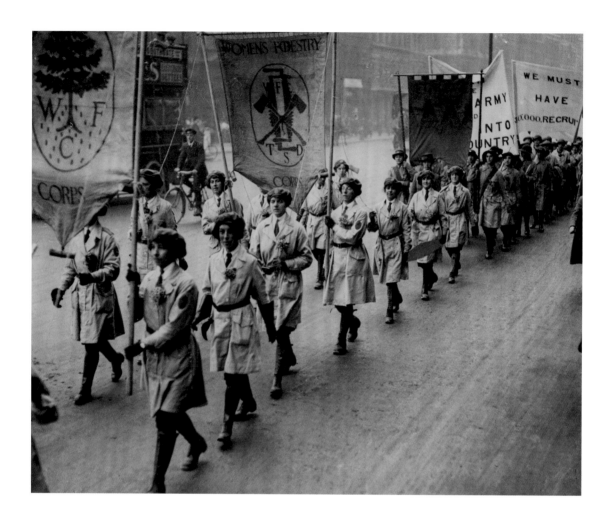

The Women's Land Army on a recruiting march, April 1918: here, the procession is coming up the Haymarket. Organisers of the WLA believed that a national association would help convince farmers, potential recruits and the general public about the role that women could play in agriculture – not only in wartime, but in the years to follow. They faced major obstacles: in the previous century, the role of women in agriculture was diminished as changes to farming practices created a clearer division of gender roles. However, the vulnerability of British imports to German U-boats created the incentive for the WLA's organisers, as cultivation of the land was essential for victory.

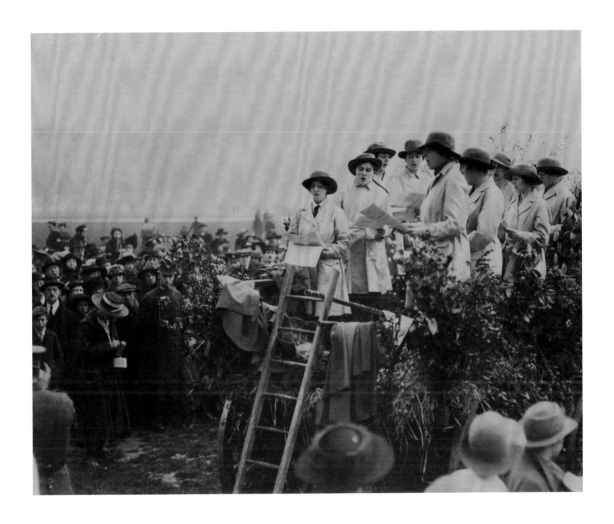

The Women's Land Army at Hyde Park in April 1918, where a women's choir are reportedly singing 'A Farmer's Boy'. Recruits who signed on for a year to the Women's Land Army were provided with a free uniform, worth around 30 shillings. Women workers were allowed to wear breeches to give them the same freedom of movement as men when doing physical work, although the Land Army Agricultural Section Handbook, issued to all members, cautioned against excess: 'You are doing a man's work and so you are dressed rather like a man, but remember just because you wear a smock and breeches you should take care to behave like a British girl who expects chivalry and respect from everyone she meets'.

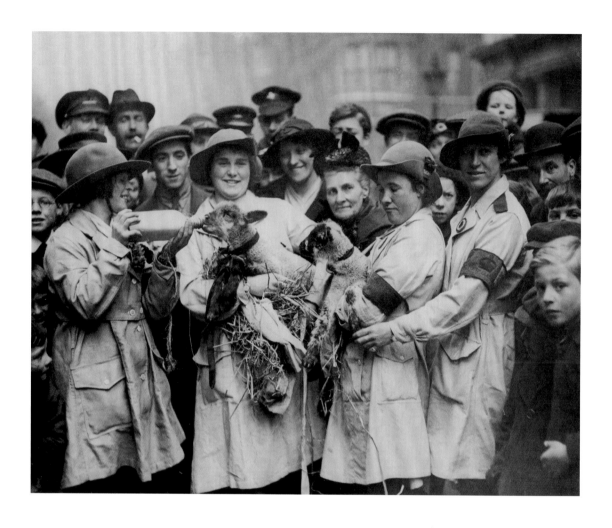

Members of the Women's Land Army feeding lambs during the recruiting march, April 1918. The promotion of a Land Army culture offered a solution to the myriad social, economic and gender struggles experienced by women before and during the war. An advert for Woman Power Insurance in *The Landswoman* (July 1918) even claimed that 'woman power' throughout the British Empire stood out as 'the most wonderful feature of the war'.

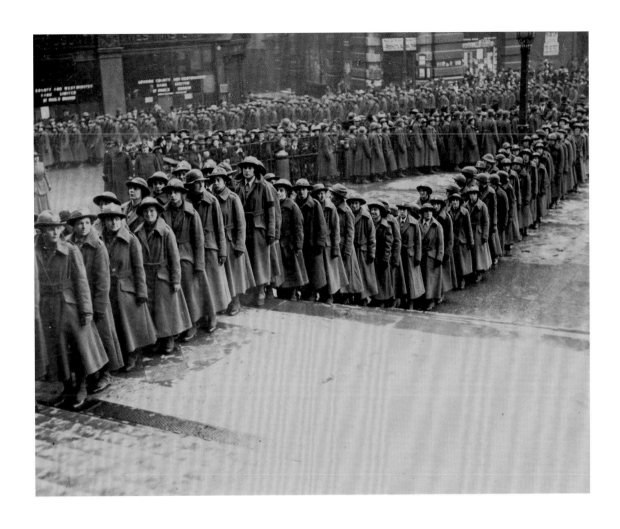

Members of the Women's Land Army entering St Paul's Cathedral, forming an escort for the Lord Mayor of London, Charles A. Hanson, in April 1918.
The organisation was invested in creating a positive experience for women in farming and aimed to create a new place for women in industry. Although the resumption of foreign imports and the return of men from the front lines would mean the WLA's prominence was temporary, it did ensure that when war returned in 1939 the British government already recognised the value of women agricultural workers in the domestic economy.

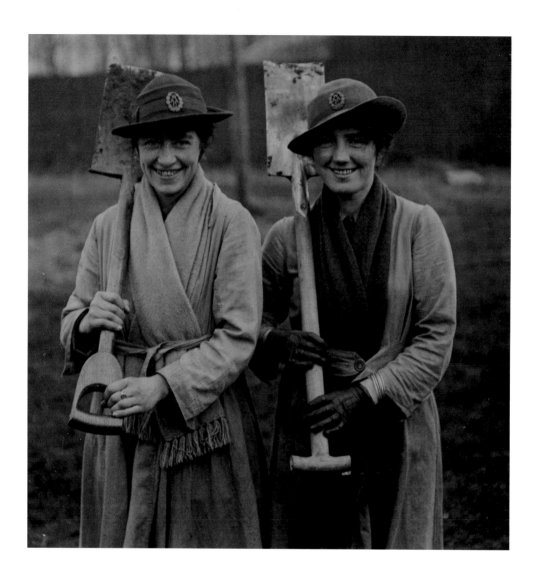

▲ **Two members of the Women's Auxiliary Army Corps (WAAC).** The work available in the WAAC was varied and reasonably paid. Recruiting posters offered 'Work at home and abroad with the forces – good wages, uniform, quarters, rations'. Jobs were available in catering, storekeeping, maintenance and administration, with training opportunities in such broad areas as driving, gardening, shoemaking, painting, photography and welding.

▶ **An extruder machine at the Chilwell National Shell Filling Factory, Nottinghamshire.** In 1918, the factory employed nearly 10,000 people, 4,000 of whom were women, and increasing production was vital as the war reached its climax. The greater labour saving was the development of an extruder machine used for the first filling of the shells. One such machine operated by two women freed up six men whilst simultaneously increasing output by 50%. On 15 June 1918, a record 46,725 shells were filled in a 24-hour period.

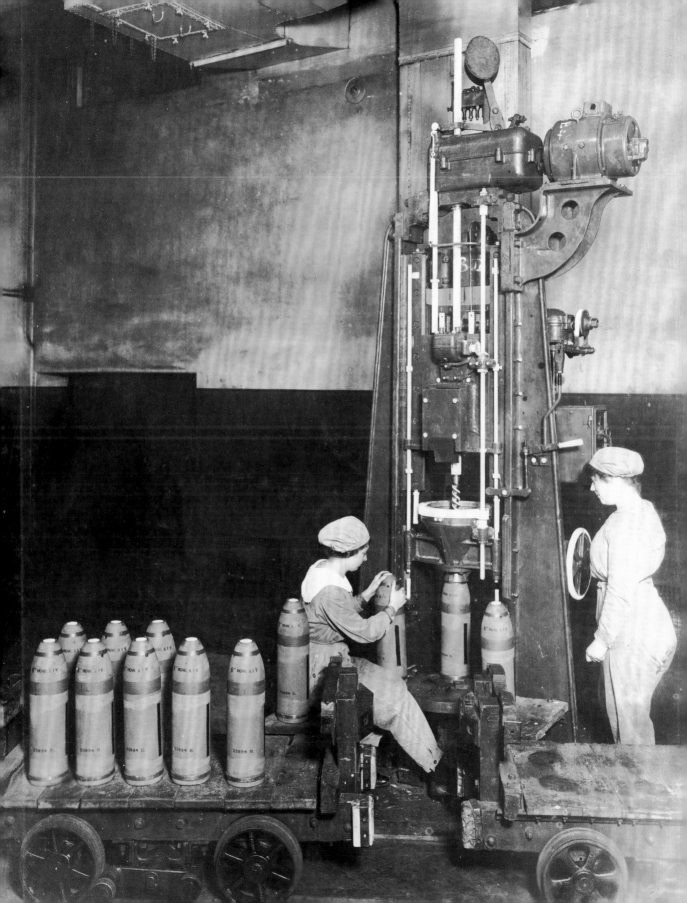

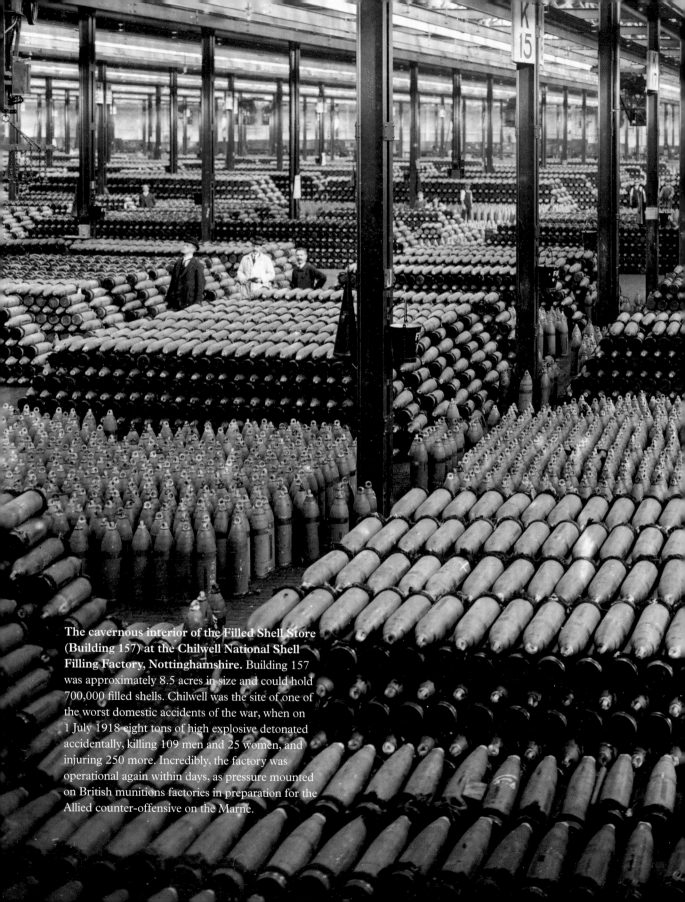

The cavernous interior of the Filled Shell Store (Building 157) at the Chilwell National Shell Filling Factory, Nottinghamshire. Building 157 was approximately 8.5 acres in size and could hold 700,000 filled shells. Chilwell was the site of one of the worst domestic accidents of the war, when on 1 July 1918 eight tons of high explosive detonated accidentally, killing 109 men and 25 women, and injuring 250 more. Incredibly, the factory was operational again within days, as pressure mounted on British munitions factories in preparation for the Allied counter-offensive on the Marne.

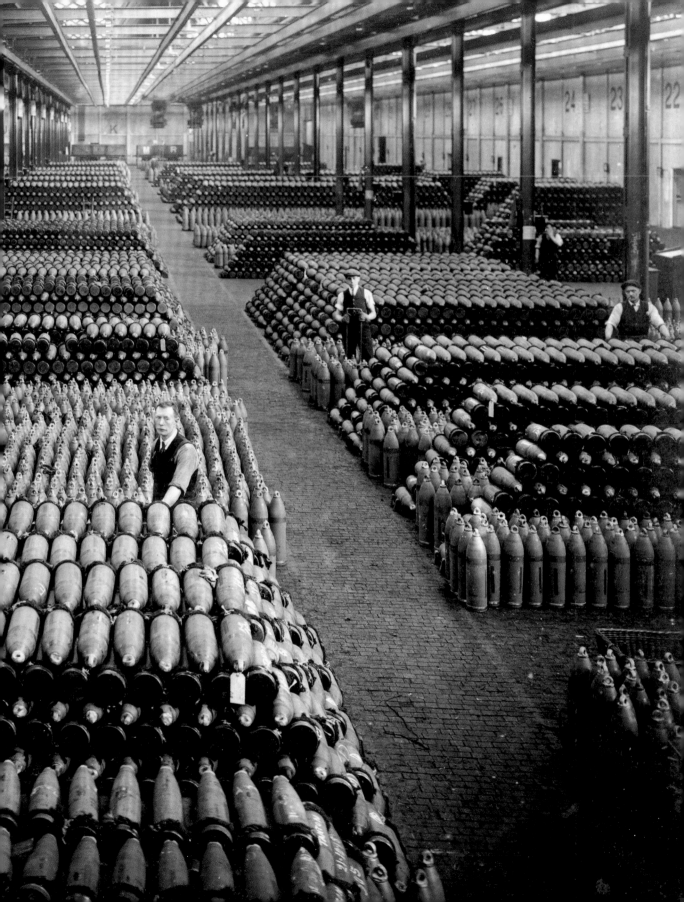

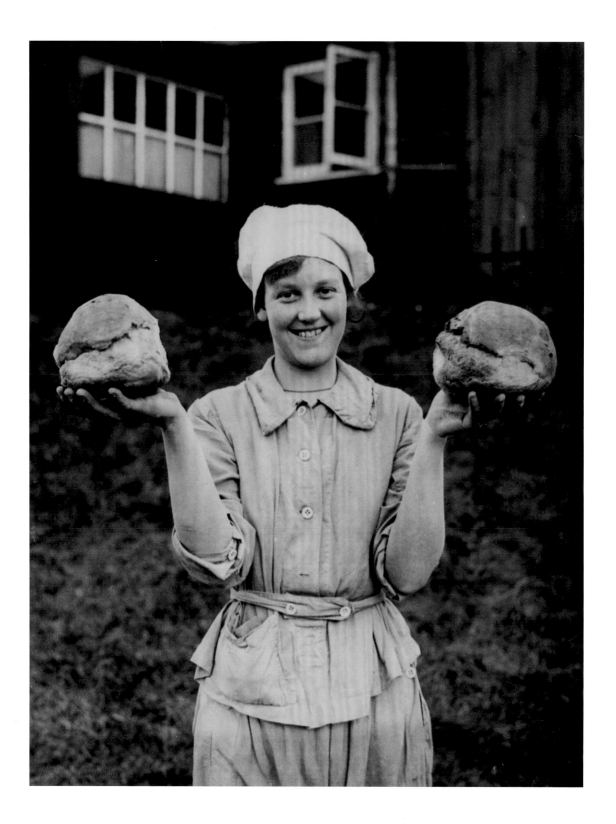

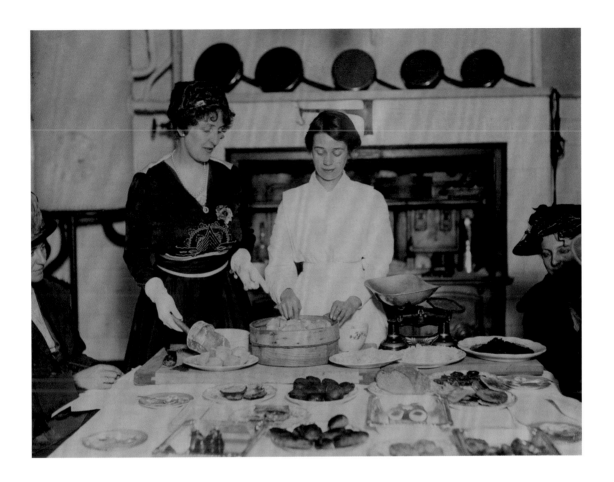

◄ A member of the Women's Auxiliary Army Corps at the British Army bakery at Dieppe, 10 February 1918. After transfer to France, the first recruits were based in Abbeville, before the number of bases expanded to other cities including Rouen, Dieppe, Le Havre, Étaples, Boulogne and Calais. Private Thomas Fuller wrote in May 1918: 'The WAACs can cook much better than the old Army cooks used to, so we shall miss them when we go up the line'.

▲ A kitchen as laid out by the Ministry of Food, March 1918. Due to food shortages brought on by submarine warfare, staples such as bread and flour were very hard to get in wartime Britain. In 1917, the government introduced a voluntary rationing scheme which was endorsed by the Royal Family; King George V issued a proclamation that everyone should cut their bread consumption by a quarter. The Food Controller encouraged local authorities to set up National Kitchens and Restaurants, where ostensibly healthy and nourishing food was served at cost, using food, fuel and labour effectively. The women who volunteered to run the kitchens described their work as 'canteening'. By late 1918 there were over 360 kitchens nationwide.

Workers at the Wilkinson Sword factory in Acton, London. Founded in the eighteenth century as a manufacturer of swords, Wilkinson Sword produced more than two million bayonets during the war. Despite all infantrymen being issued with bayonets as standard, most bayonets were unsuitable for the warfare seen on the Western Front. It was only in the close confines of trench warfare that men came face to face with the enemy, at which point a lengthy rifle and bayonet combination was more of a hindrance.

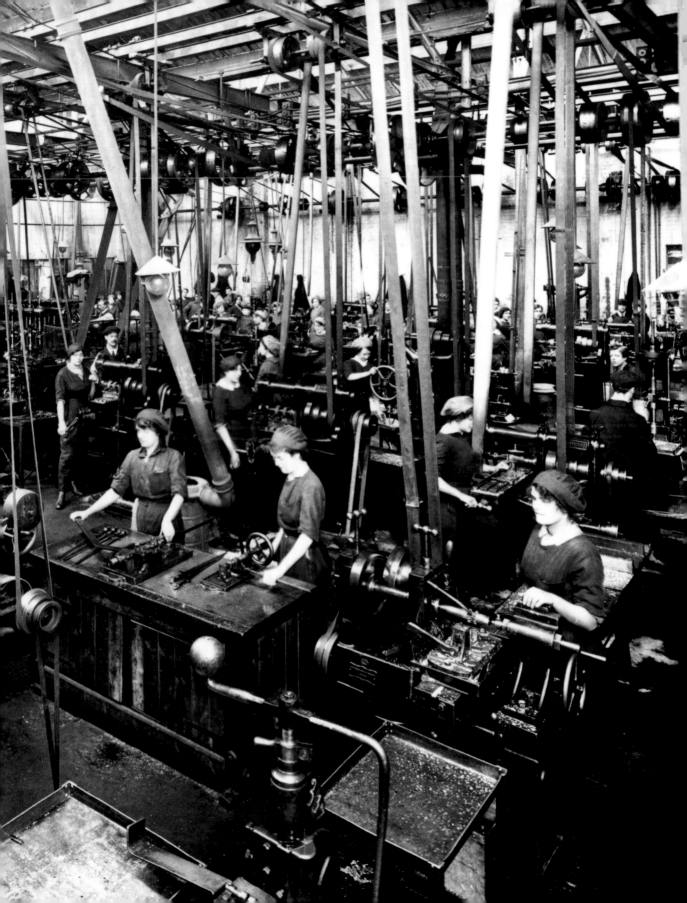

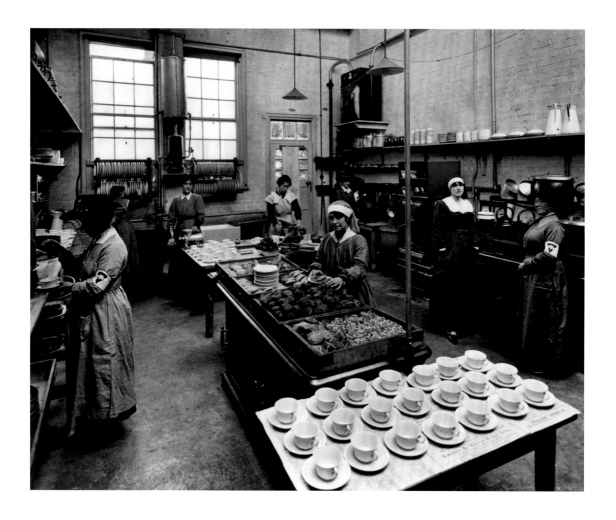

▲ **Women in the kitchen of the Wilkinson Sword factory in Acton, London.** The photograph was probably taken close to Easter 1918, as indicated by the hot cross buns on the table. Two women from the YMCA are in the kitchen – an organisation that made great efforts to raise awareness of troop conditions during the war (including the creation of mock dug-outs), to demonstrate the circumstances in which soldiers were fighting.

▶ **Washington D.C.** became the first city in the United States to have a female police traffic officer. Leola N. King, a school teacher from Delaware, joined the force in September and assumed her duties on 1 November 1918. At the end of the year, the chief of police requested thirty more policewomen to work as traffic police, providing they had 'a social conscience' and 'a desire to help humanity'. A Women's Bureau was established by the District of Columbia, but it was not until well into the 1920s that Congress passed a law that ensured D.C. policewomen holding similar responsibilities to their male counterparts would be granted the same rank.

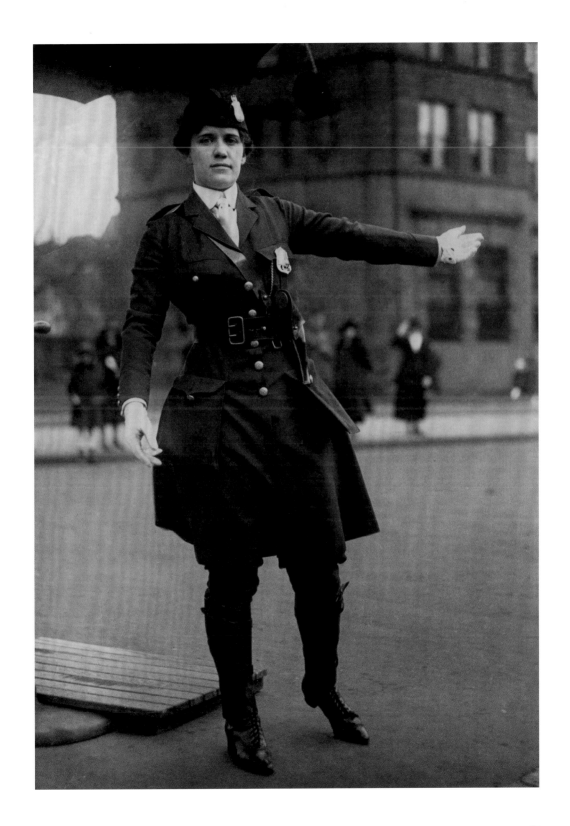

✈ Chapter Three ✈

TO THE SKIES

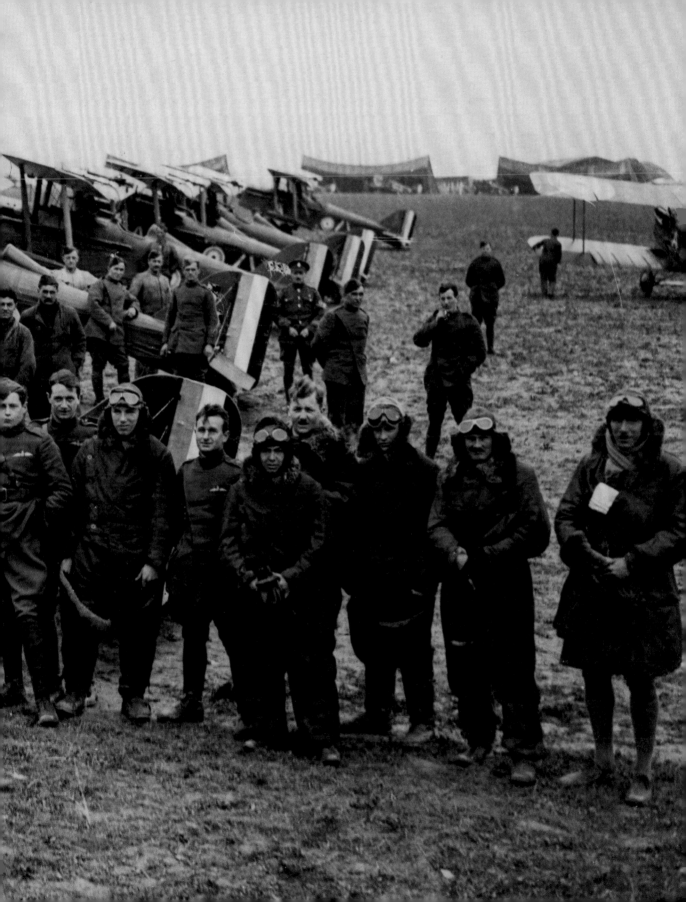

The First World War was the first major conflict involving the widespread use of aircraft. In 1914, aeroplanes were just coming into military use, and at first there was scarcely an air war at all. Bombing was in its infancy, and planes were used initially only for reconnaissance since the skies were such an unfamiliar place for combat. Early sorties involved ludicrous attempts to throw grenades or grappling hooks at passing enemy planes: only in October 1914 were machine guns mounted inside aircraft, and even then, planes needed to fly alongside each other just yards apart. As the war progressed, a critical factor in planning a land offensive was control of the air space over both friendly and enemy lines. This enabled reconnaissance planes to identify enemy batteries, highly-detailed maps to be drawn up from aerial photography, and troop movements to be charted on battlefields several hundred square miles in size.

The war saw tremendous development in aircraft technology and production. At the outset, pilots received little training and so needed planes that were stable and simple to use. A typical British aircraft in 1914, the BE.2c, had a top speed of 72 mph and could remain aloft for three hours. Four years later, manoeuvrability and power had become the top priorities: fighter planes could reach 138 mph, and bombers could remain airborne for eight hours. Technical prowess enabled rapid swings in superiority between one side and the other, when even a relatively minor development could bring swift and dramatic benefit, and combat tactics continually evolved to match. In 1917 a new generation of British fighters – the SE.5, Sopwith Camel and Sopwith Pup – enabled the Allies to regain and retain air superiority.

Such ebbs and flows enabled minor celebrities to be made of the most successful fighter pilots.

The first unofficial 'ace' of the First World War was French pilot Roland Garros, who was credited with six victories by the French Air Force before he was shot down in April 1915. The most successful was the German Manfred von Richthofen (the 'Red Baron') who had no fewer than eighty victories in the air. A national hero in Germany, he was the leader of the *Jagdgeschwader 1*, a fighter wing of the German Air Force that was nicknamed the 'Flying Circus' because of the bright colours of its aircraft (and its repeated transfer from one theatre of war to another). Richthofen's Fokker triplane DR.1 was painted red, which not only earned him his moniker but also served to distinguish his aircraft in the increasingly crowded skies. Early in his career, Richthofen, in an Albatross D.II, shot down British 'ace' Lanoe Hawker who was flying the older Airco DH.4: the fact that a relatively inexperienced German pilot in a newer plane could shoot down Britain's best pilot demonstrates that technology rather than skill or experience could be decisive.

In 1917 and 1918 the war in the air took a dramatic leap forward as both sides began to experiment with long-range strategic bombing of targets deep behind the lines. Early bombing had been entirely opportunistic on the British side, but the Germans, to great effect, used the enormous lumbering Zeppelin airships to attack Britain from bases in Belgium. In 1917 these were replaced with three-seater Gotha G bombers carrying a 1000-pound payload. The ensuing raids caused panic in London far beyond their strict military value and forced 300,000 citizens to seek shelter in underground stations, with one attack on Liverpool Street station causing 162 deaths. Eventually a defence system was improvised that first forced the Gothas to switch to night raids, and then to abandon them altogether. Meanwhile, British

recruiting posters made much of the threat: 'It is better to face the bullets than be killed at home by a bomb – join the Army at once and help stop an air raid'. All in all, over 800 fatalities were caused by the Gotha attacks, and the scarring to Cleopatra's Needle on London's Embankment remains a visible result of one such German bombing raid.

Arguably the greatest impact of air power in the last months of the war came in Palestine. General Allenby's resumption of the offensive north of Jerusalem began almost a year after he entered the city. At dawn on 20 September, the Royal Air Force and Royal Australian Air Force began a bombardment of roads, railways and troops that disrupted the German and Turkish defences and cut off their command posts. Allenby's advance, enabled by an aerial barrage that delivered 1,000 shells per minute, saw him move into the Jezreel Valley and then to Nazareth, covering forty miles in a single day. To the east, the most overwhelming air attack of the war was mounted as Turkish troops tried to reach the Jordan from Nablus: in three days, almost 20 tons of bombs were dropped from more than 50 planes as the Turks attempted to escape down a narrow wadi. Hundreds were killed. Far from the Western Front, it was a kairotic moment in the development of air attacks on moving troops. Turkish troops fell back to Damascus and the city capitulated on 1 October.

By November 1918 Britain had 3,300 frontline aircraft and Germany 2,600, whilst the Americans mustered close to 750. These were much higher performance machines than in 1914, meaning losses in the air were far greater. Britain alone lost more than 2,500 aircraft during the Hundred Days Offensive and – as in previous years – new pilots had little time to be trained. It remains a source of wonder that recruitment proved so successful, particularly given that the life expectancy for a new pilot was assessed at little more than a month. The creation in April 1918 of the Royal Air Force, merging the Royal Flying Corps and the Royal Naval Air Service, was a notable indicator of renewed investment in air power, as well as its independence from the British Army and the Royal Navy. By now, aircraft had evolved from mere curiosities to major weapons of war. More than anything else, the war in the air anticipated the aerial combat, sustained bombing campaigns and strategic support of 1939-45, where air power, rather than traditional sea power, would reign supreme.

PREVIOUS PAGE

SE.5a fighter planes from No. 32 Squadron (as indicated by the white markings behind the roundel). Formed in 1916 as part of the Royal Flying Corps, the squadron was originally equipped with Airco DH.2 and DH.5 aircraft. It was then reequipped with the SE.5a in December 1917, which was flown for the rest of the war on fighter and ground attack missions. On the photograph can be seen where the censor has scratched out some of the squadron markings on the tailfins.

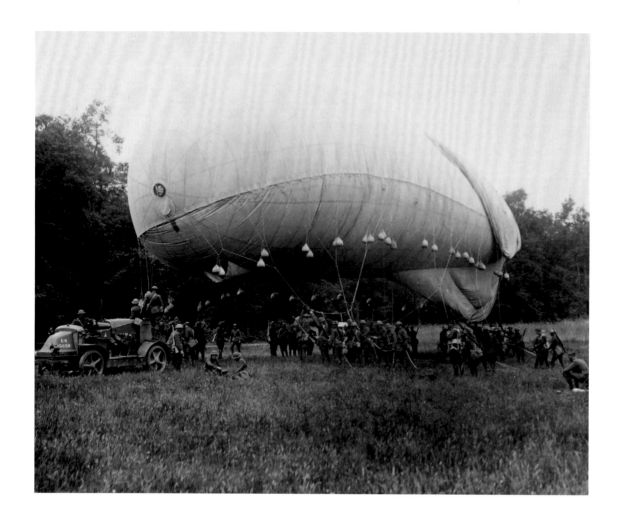

▲ American troops attaching an observation balloon to a winch. The balloon, tethered to a thousand-yard steel cable, was driven by car to a key location, and two observers went up to take photographs and to identify any changes in enemy supply camps, ammunition dumps or trench layouts. Needless to say they were a target themselves, both for artillery fire and enemy aircraft, a fact not helped by the balloon being filled with hydrogen. Balloonists were the first military aeronauts to get parachutes.

▶ Female fitter working on the Liberty engine of a De Havilland DH.9A. During the war, members of the Women's Royal Naval Service and the Women's Army Auxiliary Corps worked on air stations belonging to the Royal Flying Corps (RFC) and the Royal Naval Air Service (RNAS). When the RFC and RNAS was merged into the Royal Air Force, concerns were raised about the loss of their specialised female workforce, led to the formation of the WRAF on 1 April 1918. The most highly skilled were assigned as technicians, including tinsmiths, fitters and welders.

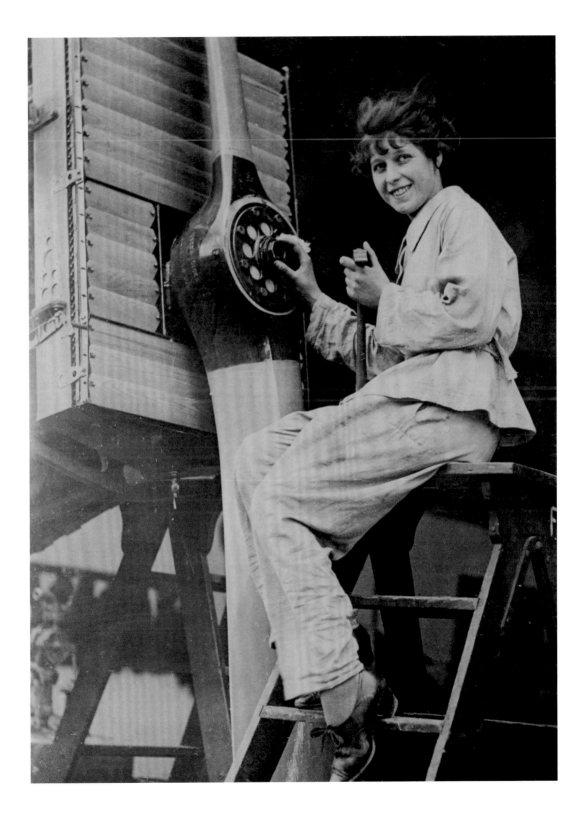

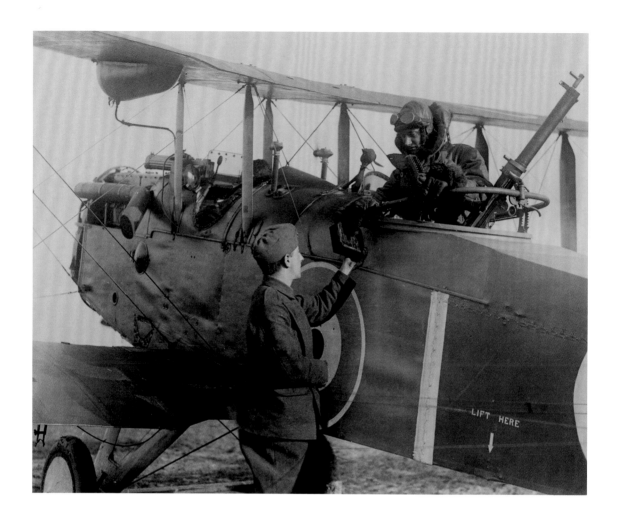

An air mechanic being handed photographic plates by the observer of an Airco DH.4, March 1918. The plates contained evidence of the places bombed, trench positions and troop movements, in order to compare with pre-issued maps. Since maps were of little use unless prospective targets could be pin-pointed, aerial photography was key to this development. Air reconnaissance did help to identify likely danger points in March 1918, but for days before Operation Michael heavy cloud and rain prevented early morning flights.

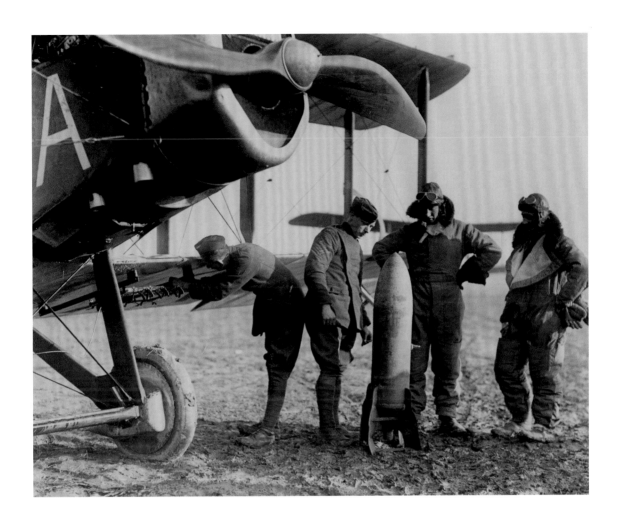

Probably the same Airco DH.4, seen here from the front, March 1918.
The observer stands to the right, with the pilot beside him. Armed at the front with
a single forward-firing synchronised Vickers machine gun, and in the rear cockpit
with a stripped-down Lewis gun, the DH.4 was often considered the best single-
engine bomber of the First World War. It could stay aloft for more than six hours
and carried a 460-pound payload. Several thousand were manufactured between
1916 and 1918, the majority in the United States. The war ended before the four-
engined Handley V-1500 was ready for use: had this aircraft, which could have
reached Berlin, been utilised earlier, it may have had a more dramatic effect on the
strategic bombing campaigns of 1918.

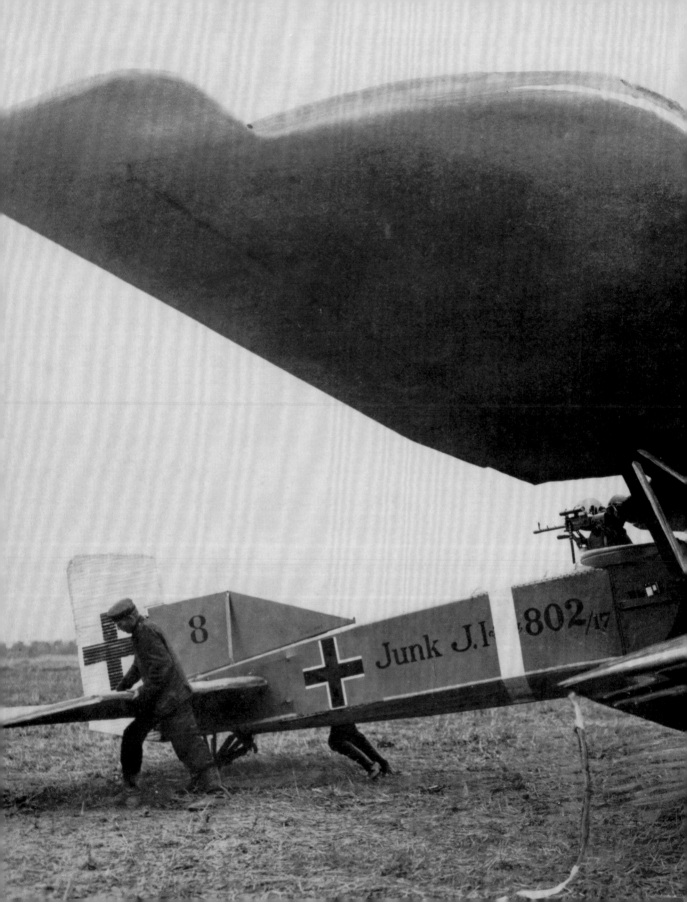

A captured Junkers J.I. Developed in 1917, it was the world's first mass-market all-metal aircraft and saw widespread use during the German spring offensive. The engine and two-man crew were protected from enemy ground fire by a nose-capsule made of 5 mm-thick chrome-nickel steel plates. This made it durable but heavy, and the Junkers J.I took a long time to get airborne, earning it the nickname 'the furniture van'. It was primarily used for low-level reconnaissance and ground attacks, and the strength of its metal structure eliminated the need for external bracing wires that could be easily severed by enemy fire.

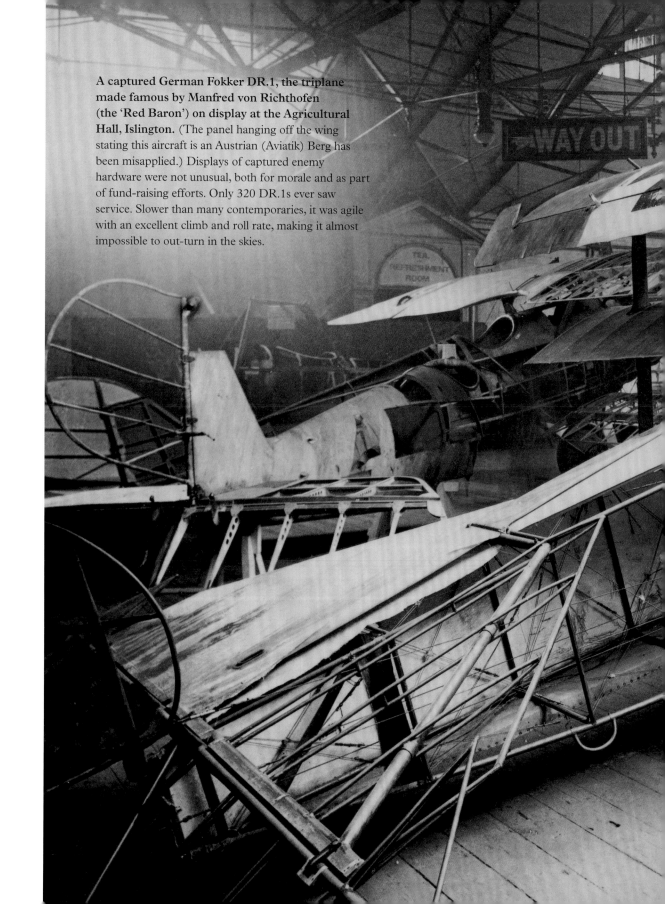

A captured German Fokker DR.1, the triplane made famous by Manfred von Richthofen (the 'Red Baron') on display at the Agricultural Hall, Islington. (The panel hanging off the wing stating this aircraft is an Austrian (Aviatik) Berg has been misapplied.) Displays of captured enemy hardware were not unusual, both for morale and as part of fund-raising efforts. Only 320 DR.1s ever saw service. Slower than many contemporaries, it was agile with an excellent climb and roll rate, making it almost impossible to out-turn in the skies.

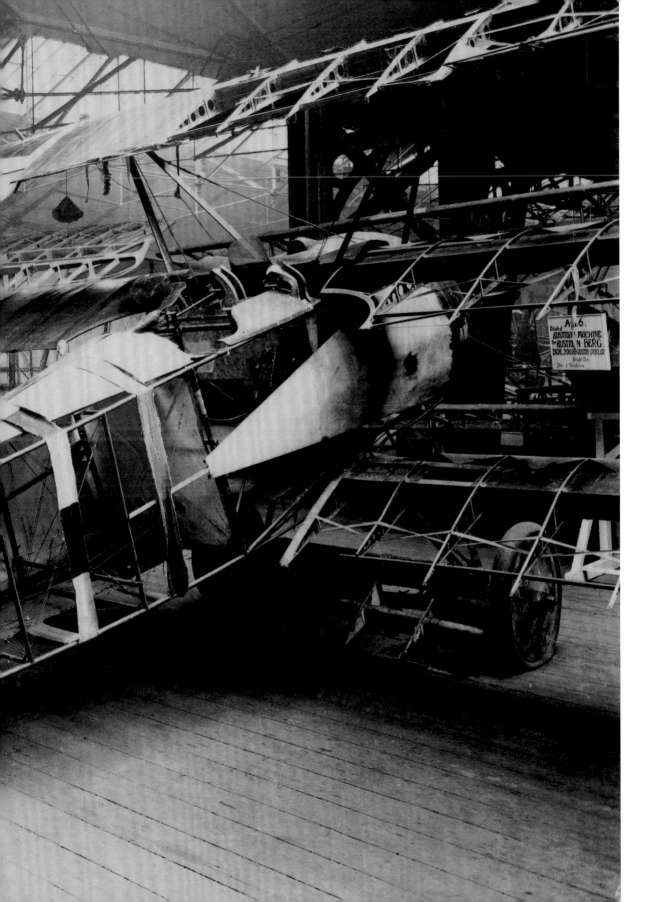

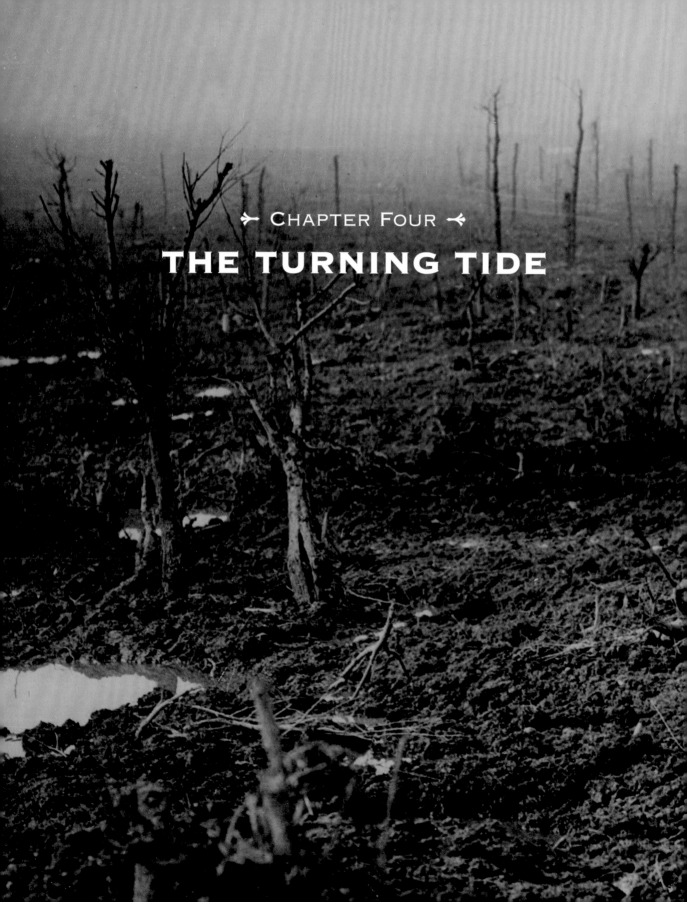

CHAPTER FOUR

THE TURNING TIDE

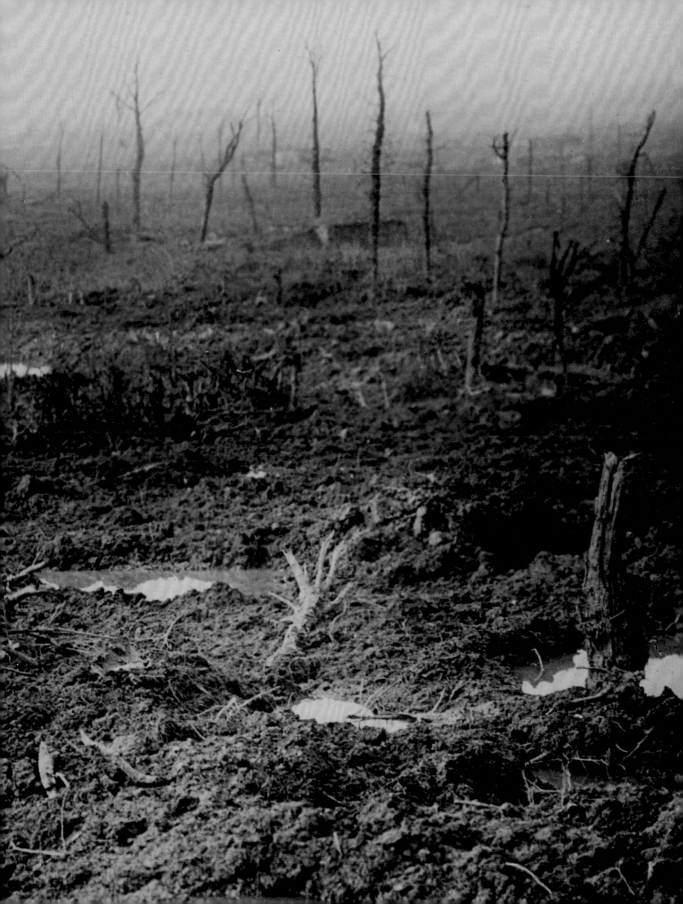

The Allied counter-offensive began on the Marne. On 15 July, the Germans had struck either side of Reims and established a bridgehead four miles across the river. Billed as an imperial battle, the Kaiser had himself emerged to rally the troops, but three days later the French commander General Mangin delivered a major riposte. Five American divisions, each 28,000 strong, joined the French; the fresh troops fought with a disregard for casualties scarcely seen since the beginning of the war. Ludendorff's repetitive tactics were increasingly being interpreted as signs that he was becoming detached from reality, and he drew severe criticism from within the General Staff.

On the night of 18-19 July, the German vanguard that had crossed the Marne three days earlier fell back, and within 48 hours the French Tenth Army had pushed forward approximately six miles. By 7 August the Germans were back to the Aisne, suffering losses of 800 guns and 168,000 men. The following day, an Allied offensive led by Rawlinson's Fourth Army aimed to free the rail junction at Amiens and push forward south of the Somme. Great secrecy surrounded the advance, and in a move that pre-empted the D-Day strategy in 1944, two Canadian battalions remained in Flanders to generate false signals traffic – the presence of Canadian or Australian troops in the line opposite generally implied to the Germans that an attack was pending. In addition, the British had begun using sophisticated location devices to pinpoint enemy guns without the need to fire range-finding shots. This reintroduced the element of surprise to the battlefield, ensuring that when the assault began, the threat of the German guns had been all but eliminated by a hail of iron.

By the end of 8 August, Australian, Canadian and British units had advanced eight miles, captured 400 guns and taken 32,000 prisoners. Ludendorff described it as 'the black day of the German Army in the history of this war'. Tribute was later paid to the Commonwealth troops who were kept together as distinct national bodies during the assault, making it easier to share tactical lessons and maintain morale. This was far from the first time that they had garnered praise. 'I hope that the Canadians are not in the trenches opposite you', wrote a German soldier in 1917, 'for they on the darkest night jump suddenly into our trenches, causing great consternation and before cries for help can be answered disappear again into the darkness'. Notably, both Canadian and Australian commanders had refused to cut the size of their divisions in response to the Allied manpower problems, so they could bring more men to bear during major attacks. Their larger critical mass meant that they could drive harder against the enemy than comparative British divisions.

The Battle of Amiens had underlined that a gap was growing between the well-supplied and reinforced Allies and the declining Germans. The two years since the Somme campaign had seen significant munitions advances in Britain, whilst a sustained naval blockade had deprived Germany of vital raw materials. As Allied forces captured German guns, they would not be replaced. This was a critical factor in the turning of the tide seen in the summer of 1918, and whatever myths were later circulated about the manner of the German surrender, there is no doubt that the army was utterly defeated in the field by more numerous and increasingly superior Allied weaponry. The emerging role of artillery in the combined arms operations, coupled with improved communications technology, was to prove crucial. Technical improvements in target identification, tactical improvements such as counter-battery fire and overhead fire (the 'creeping barrage') and

logistical improvements that allowed field artillery to be massed where it was most needed all combined to sweep away a German army worn down by the murderous campaigns of the spring. Yet it was a symptom of those turbulent days that as late as 16 August, Prime Minister Lloyd George prepared a memorandum setting out the case for delaying the decisive Western Front offensive until 1920. Haig, perhaps more convinced than the politicians of the fragility of the Central Forces (and also concerned that his troops were outrunning their logistics), was anxious to achieve an armistice in 1918. During August, Britain, France and the United States captured 150,000 German soldiers, 2,000 guns and 13,000 machine guns. Haig was able to make the unexpected request of the War Office that he be supplied with mounted men: a return to the war of movement of 1914.

On 14 August the Kaiser instructed his Foreign Secretary to open peace negotiations. Ludendorff, however, insisted on holding the front, his aim to fight once more to a standstill and at least escape outright defeat. He played for time first by abandoning the salients won in March and April – a move that demoralised his exhausted troops – and then by retiring his men into the labyrinthine depths of the Hindenburg Line. For now, the bloodshed was destined to continue, but the final card in the German pack had been played. The best they could now hope for was for their opponents to break themselves like waves on the massive earthworks, riddled with wire and snipers, that barred the way east. For their part, the Allies would need to plan their major offensive with caution: breach the Line and they might dictate peace terms; fail and they would condemn their men to static trench warfare for another year.

PREVIOUS PAGE
An all-too-familiar scene of devastation from the Western Front as the Allies pushed back against the German spring offensive: broken trees, waterlogged shell holes and deep puddles.

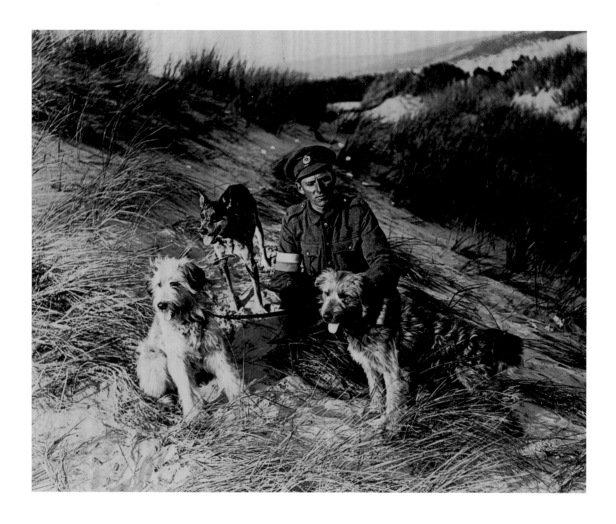

A Royal Engineer 'keeper' with his messenger dogs. The white over blue brassard on his right upper arm indicates Signals Service, and he has four good conduct stripes on his right forearm, indicating 18 years with an unblemished record. Each handler would have, on average, three messenger dogs to look after. The dogs, usually collies, retrievers or large terriers, were trained to carry messages between the lines and command HQ. They were often strays, and before being shipped to France were trained at the War Dog Training school in Shoeburyness.

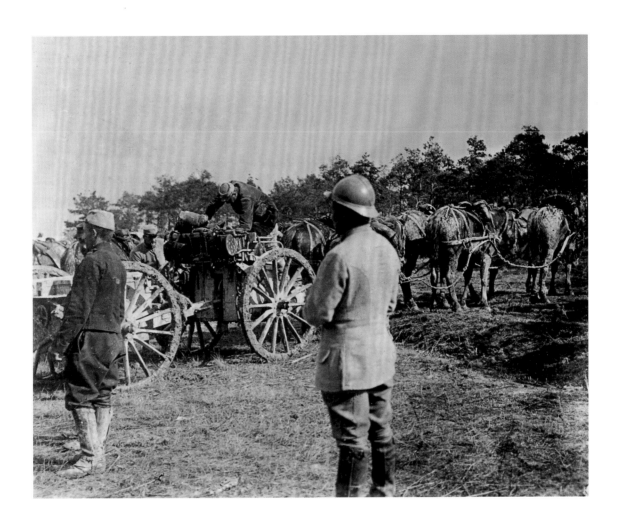

French field artillery in the village of Perthes, just to the north of the Hindenburg Line. It lay in German hands between 1914 and 1918, but fell to General Gouraud's French Fourth Army during the Hundred Days Offensive. The gap between the well-supplied Allies and their declining opponents was evident when the Battle for Amiens began on 8 August: the German guns were outnumbered more than two to one. Additionally, by using sophisticated location devices the Allies could pinpoint enemy guns without having to test the range. Increasing the element of surprise on the battlefield not only knocked out most of the German guns but also removed the main hindrance to the advancing tanks.

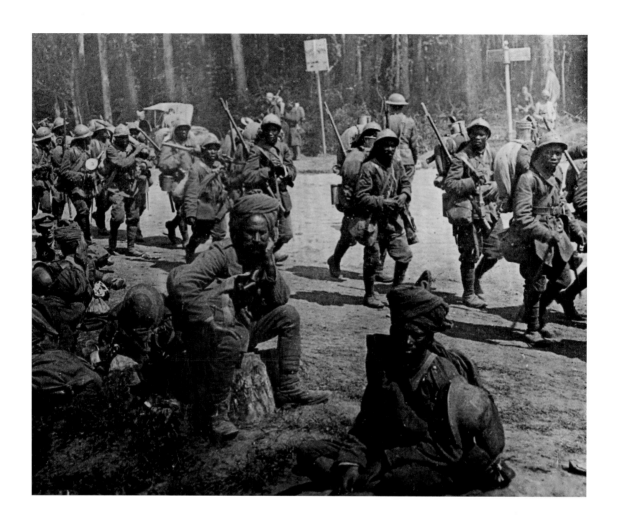

French-Moroccan troops on the Villers-Cotterets road, northeast of Paris.
The main Allied counterattack in the Second Battle of the Marne was entrusted to
General Mangin's French Tenth Army, headed by the elite XX Corps, containing
the 1st and 2nd American Divisions and the 1st Moroccan Division. The French
had amassed an unprecedented amount of artillery, 540 light and 240 medium
tanks, many of which were brought up at night and hidden amongst trees. One
French officer noted before the attack at Villers-Cotterets that the entire forest
seemed to be swarming with men and twinkling with lights.

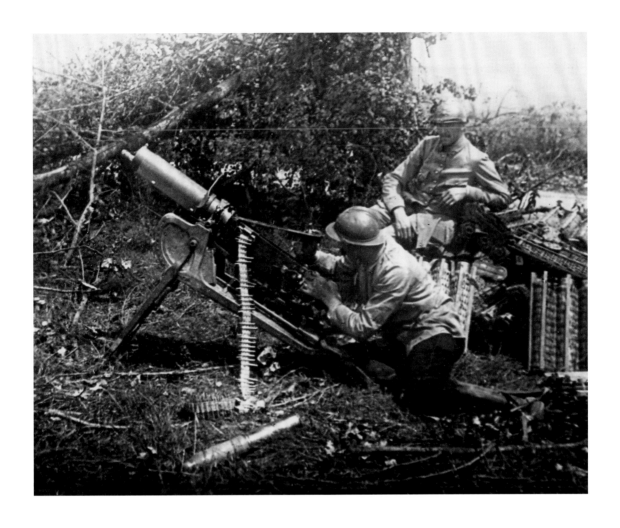

Captured German Maxim MG 08 set up for indirect fire on the road between Villers-Cotterets and Soissons, together with supplies of ammunition.
The relative bulk and weight of a mounted MG 08 served the Germans well in entrenched positions when the British and French armies attacked.

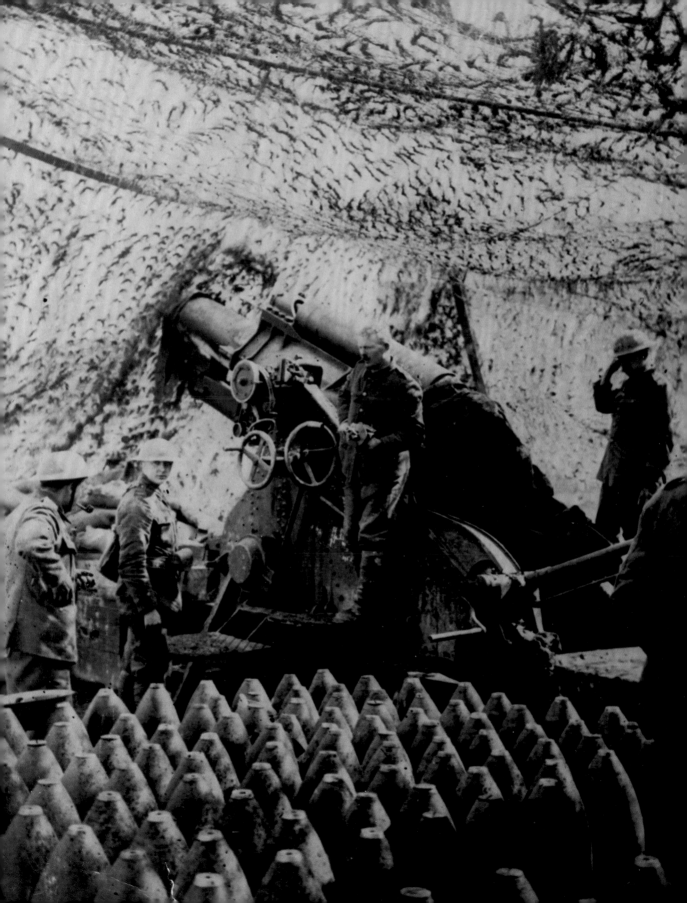

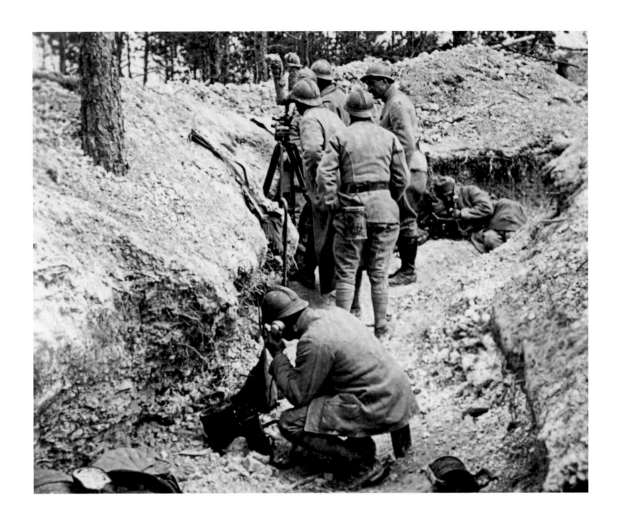

◄ **A 9.2-inch BL howitzer, the principal counter-battery equipment of British forces during the war.** The Mk II howitzer had a range of almost eight miles. The camouflage net was vital due to enemy spotter planes. During the Second Battle of the Marne, batteries were deployed in the open with ammunition stacked beside them, netted over with camouflage or covered with cut wheat.

▲ **Artillery observers in an observation post on the Marne.** The Frenchman in the foreground is using a portable field telephone, and behind him is a reel of wire that carried the connection into the rest of the trench network. To his right is a soldier with a metal can, in which is a new model of gas mask. The men are using range-finding equipment to report falling shells. Military radio technology was still in its infancy, and on the ground communications were carried out by telephone even in 1918.

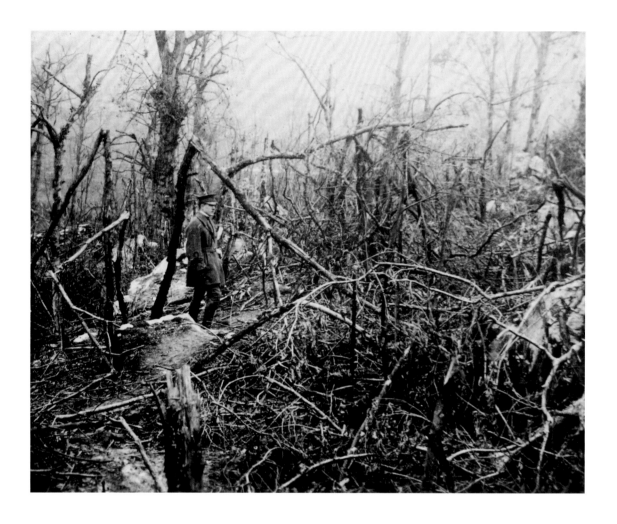

A scene from Belleau Wood, where the 2nd and 3rd American Divisions
(the former containing the 4th US Marine Brigade) rebuffed men from five
German divisions during June and July 1918. The action cost the US more
than 9,000 casualties, making the Battle of Belleau Wood one of the bloodiest
and most ferocious battles the Americans would fight during the war. According
to Marine Corps legend, the nickname 'Devil Dogs' was first used by German
soldiers to describe the Marines who fought ferociously at Belleau Wood (it had in
fact appeared in newspapers in the United States two months earlier).

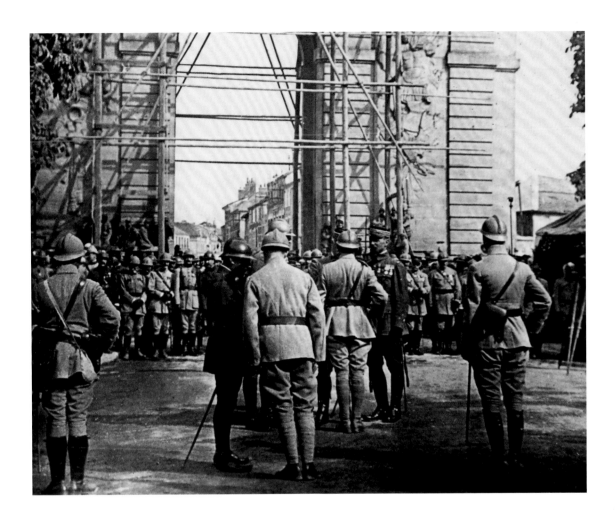

**General Gouraud awarding medals to French troops under the archway of
Fort Sainte-Croix, Chalons, July or August 1918.** The Allied resistance on the
Marne broke the back of Ludendorff's army after the final German offensive push,
Operation Marneschutz-Reims, failed in mid July. Pushing forward at the end
of long supply lines, desperately attempting to reach the French city of Reims,
the Germans proved wholly vulnerable when the Allies, assisted by accurate
intelligence, hit back.

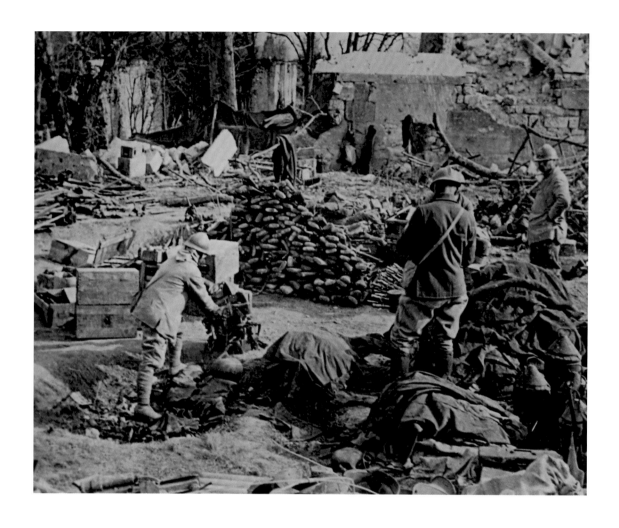

Abandoned German supplies being inventoried by the French at Soupier, France. The German army faced increasing difficulty in securing replacements for captured and destroyed weapons. By contrast, the British Ministry of Munitions under Winston Churchill's leadership was so successful that industry was able to deliver increasing quantities of Lewis guns, machine guns, trench mortars, aircraft and tanks to the front. This meant that an average British infantry division in 1918 could deliver more firepower than its 1916 equivalent, despite being smaller in number.

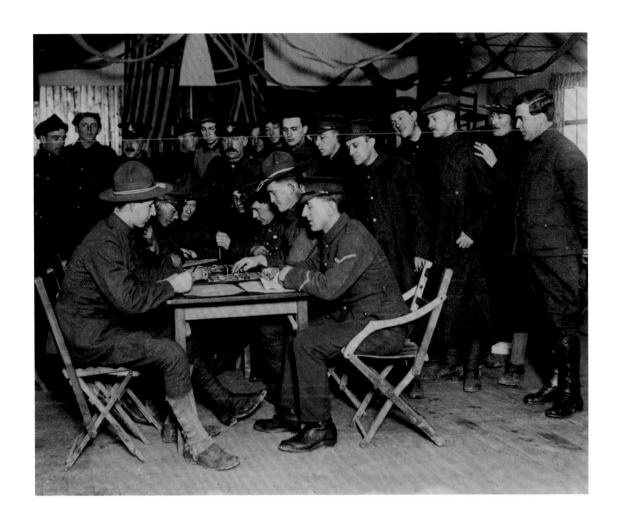

American and British soldiers playing draughts and writing letters home.
Around 1.3 million US forces had arrived in Europe by August 1918, making a
dramatic difference to the balance of power on the Western Front.

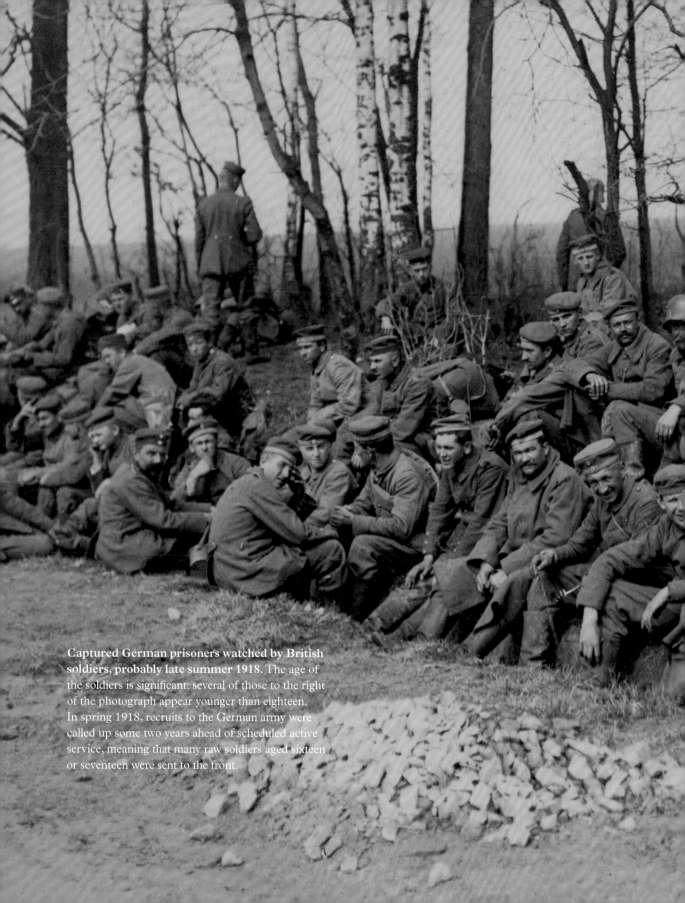

Captured German prisoners watched by British soldiers, probably late summer 1918. The age of the soldiers is significant: several of those to the right of the photograph appear younger than eighteen. In spring 1918, recruits to the German army were called up some two years ahead of scheduled active service, meaning that many raw soldiers aged sixteen or seventeen were sent to the front.

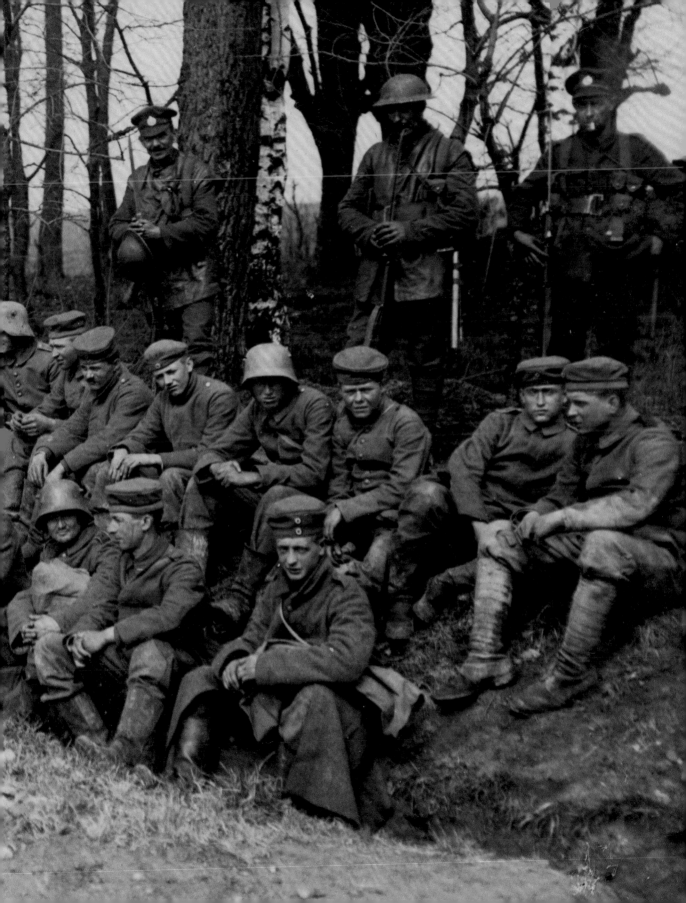

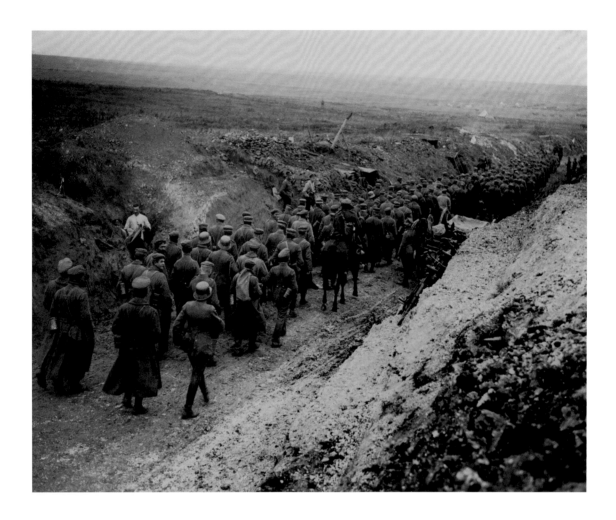

▲ German soldiers began surrendering in ever-increasing numbers during the Allied counter-offensive in the summer of 1918. German trenches and rear areas were regularly deluged with leaflets, dropped from aircraft, urging them to give up the fight; morale in the armies was already low due to cancelled leave and scarce opportunities for rest. In response, senior German officers issued desperate orders to quell the rumours of imminent defeat.

▶ Troop surrenders were a key indicator of the Central Powers' decline: approximately 340,000 Germans surrendered between 18 July and 11 November, playing a major role in weakening the army and bringing about an Allied victory. Recent research suggests that most German units surrendered in an orderly fashion, with the full participation of their junior officers who supervised and negotiated the capitulation of the men in their command.

✦ CHAPTER FIVE ✦

TOWARDS
THE END

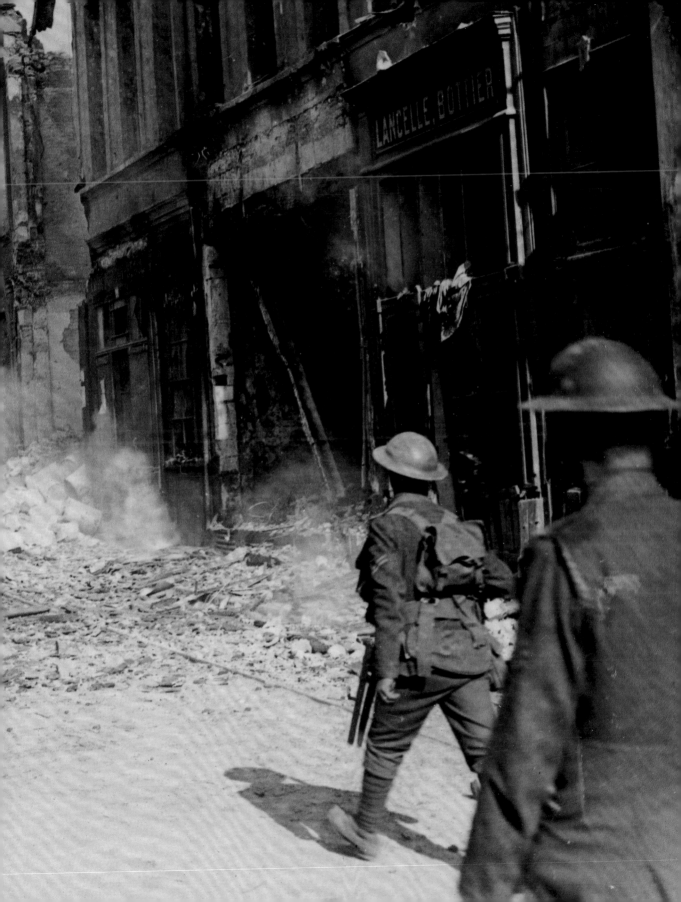

By mid September, almost the entire Western Front was alive. The Germans were either being outfought or outsmarted, and by the middle of the month the Allies were in touching distance of the formidable Hindenburg Line. As plans for the general offensive on the Western Front were finalised, key developments took places in other theatres of the war. In Palestine, Allenby's breakthrough at Megiddo forced the Ottoman armies into hasty retreat, whilst in Salonika, the Bulgarians sued for peace after a decisive Allied attack. Events in the Balkans would precipitate peace, just as they had led the descent into the abyss. Ludendorff knew that the Bulgarian armistice bid would wreak havoc with the Central Powers' lines of communication: Austro-Hungary's southern border would be threatened and the Ottomans isolated. Moreover, any Allied advance into Romania would cut off supplies of oil to the German troops. The noose was beginning to tighten.

For the Germans, the incessant flow of American troops punctured their four-year conviction that, man for man, they were able to defeat the Allies. From nowhere could the German armies drum up sufficient men to match the resources arriving from across the Atlantic, nor resist the growing sense that the climax of the war was upon them. At St Mihiel, for example, the Germans could no more match the fervour of the 200,000 US troops facing them (most in action for the first time) than they could withstand the 100,000 rounds of phosgene gas shells with which they were bombarded. A sense of pointlessness became almost overwhelming: Crown Prince Ruprecht recorded seeing a troop train at Nuremberg bearing the inscription 'Slaughter cattle for Wilhelm and Sons'.

In the final week of September, Allied commanders initiated four coordinated attacks.

The first, by French and American troops, was in the Argonne region on 26 September. The exuberance of the American forces was matched only by their tactical naivety, and the attack soon ground to a halt in wooded terrain. Nevertheless, they succeeded in bottling up no fewer than thirty-six German divisions – something of incalculable importance as other attacks progressed. The second wave, launched the following day by the British First and Third Armies, was to the west of Cambrai. Bolstered by the Canadian Corps, the Allies crossed the Canal du Nord at pace, and moved six miles in two days. Third, on 28 September in Flanders, Belgians forces under King Albert broke out of the old Ypres Salient and retook the infamous Passchendaele Ridge.

The final attack came against the Hindenburg Line itself. Daunting and intimidating, the *Siegfriedstellung* or Siegfried Position had been constructed in the aftermath of the Somme offensive in 1916. This heavily-fortified network of trenches and bunkers – 85 miles long, made of 100,000 tons of concrete and 12,500 tons of barbed wire – was created by forcibly evicting 125,000 French residents from occupied territory and methodically laying waste to the countryside. Three miles deep in places, it was intended to shorten the German front and enable the remainder to be held by fewer troops. To win the war, the Allies needed to breach it.

On 29 September 1918, a four-day preparatory bombardment dropped 750,000 shells on the Line before the British Fourth Army began to move. To the right of the assault was the intimidating stretch of the St Quentin Canal, with steeply-sloping banks some 50-60 feet high. To the left, the canal ran underground, and it was here that the assault began. At first, progress was halting: the tanks could make little headway against the canal tunnels,

and powerful defences held up the attackers. To the north, however, the situation was redeemed. Far-sighted preparations by the 46th (North Midland) Division included collapsible boats, floating piers and life jackets obtained from Channel steamers. Screened by fog on the day of the assault, they crossed the 35-ft wide canal and captured a key bridge at Riqueval. By the standards of the war, it was a spectacular success. As the day ended, the 46th could look at a gash in the Hindenburg defences upwards of three miles in length. A few days later, the French entered St Quentin as another set-piece assault tore open further deep wounds in the German position. By 5 October the Allies were pouring through the Hindenburg Line into open country.

Ludendorff had already seen the end. On 28 September, as the attacks came from almost every quarter and the Bulgarians began armistice talks in Salonika, he had finally broken, ranting and raging behind closed doors. Finally, he informed Hindenburg that no alternative remained but to seek an armistice. The following day, the Kaiser signed a proclamation establishing a Parliamentary democracy; on hearing the news, Lenin became convinced an international Bolshevik revolution was in the offing. The coming weeks saw a flurry of diplomatic activity as Germany sought the least disadvantageous position from which to close the war. With mutiny in the fleet, widespread strikes, thousands at risk of starvation and revolution in the air, little room for negotiation really existed. On the chilly night of 7 November, a German delegation crossed the French lines to commence discussions, and two days later the Kaiser – grey, emaciated and broken – announced his abdication and slipped silently over the Dutch border into exile.

PREVIOUS PAGE

A patrol of the North Lancashire Regiment marching into Cambrai. The Second Battle of Cambrai took place in October 1918, eleven months after the first. British and Canadian troops used many of the newer tactics seen in 1918 as the Germans were driven from the town.

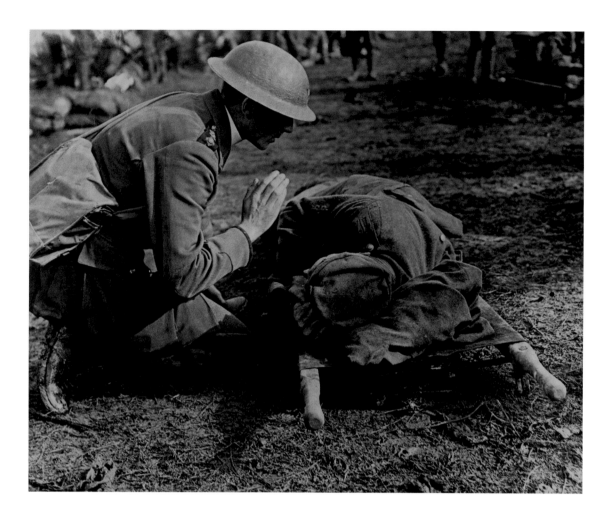

A British padre saying a prayer over a dying German soldier at an advanced field dressing station near Epehy, 18 September 1918. The lives of thousands of clergymen were shaped by their experiences ministering to soldiers in every theatre of war. They played an important role in the maintenance of troop morale, as well as providing an important channel of communication between the army and a civilian population suffering unparalleled grief. In his memoirs, Harry Blackburne, Assistant Chaplain-General of the First Army, recorded: 'I nearly wept with joy when one General said that the chaplains were more trusted than anyone'.

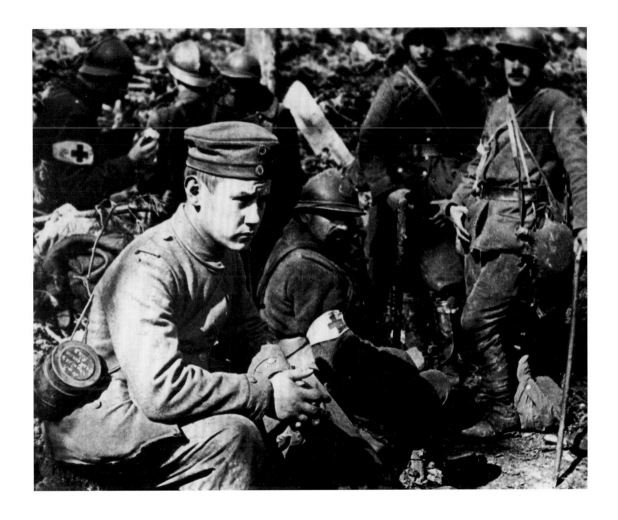

A young German prisoner. As Ludendorff's offensive foundered, the lack of experienced replacement troops meant that youths from the class of 1920 were the main recruits in 1918 – a problem highlighted by the losses of highly-skilled storm troops during the spring and early summer. Until mid 1918, Britain and France, with their effort focused on the virtually static Western Front, took far fewer captives than Germany, Russia or Austro-Hungary.

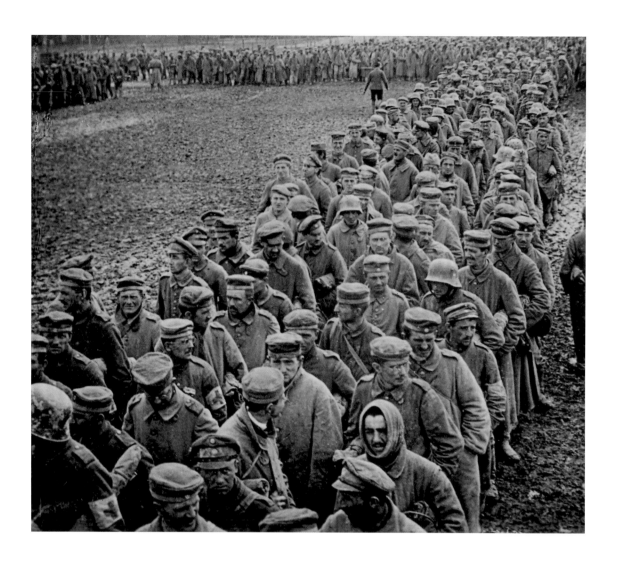

1900 German prisoners captured by American troops, August or September 1918. Several of the prisoners are still wearing their heavy steel trench helmets, whilst others wear round grey caps with red bands. NCOs wear visored caps. To the bottom left, two men, part of a medical detachment, wear Red Cross armbands.

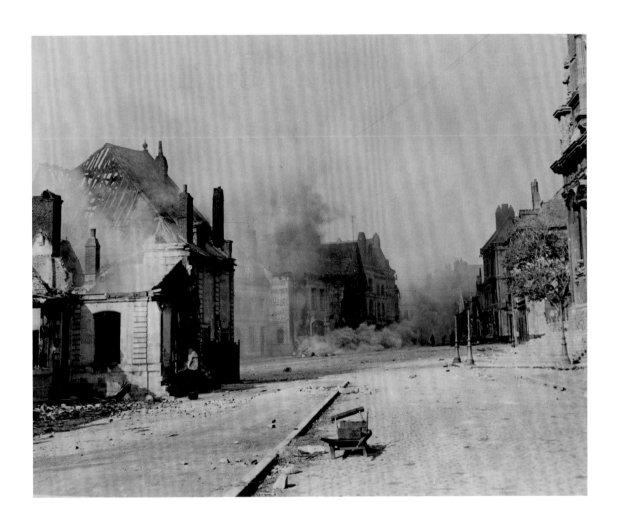

Ruins of Cambrai, captured after a ten-day siege when the 3rd Canadian Division entered the town at dawn on 9 October 1918. It was a major achievement by the Allied armies resulting in remarkably little loss of life, although celebrations were muted due to the large number of fires left blazing after the German retreat.

A picture palace in Cambrai frequented by Germans during their occupation of the town. It gives a sense as to how long the Germans occupied Cambrai (and how permanent they intended that occupation to be – an attitude that also characterised their trench-building) that they took the trouble not only to put instructions on the walls (*Reserviert für Offiziere, Rauchen Verboten*) but also to decorate it with the names of movie actresses.

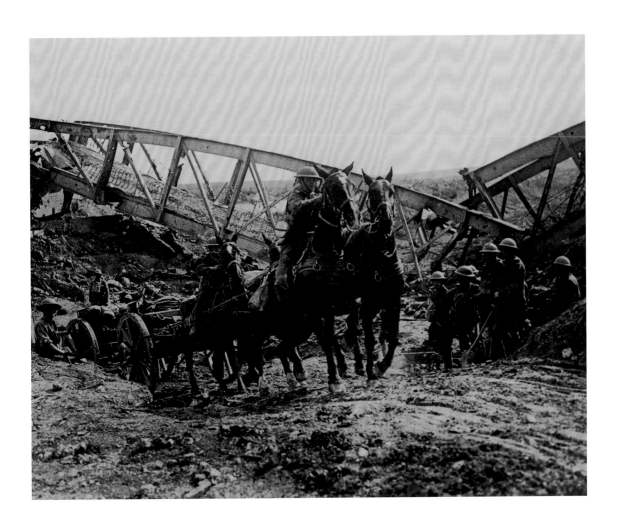

A horse team of the Royal Field Artillery pulls an 18-pounder QF field
gun up a slope through the bank of the Canal du Nord near Moeuvres,
27 September 1918. It was crucial to ensure that the artillery kept up with the
main advance. The Canal du Nord acted almost as a moat in front of the German
defences around Cambrai: an intense artillery barrage enabled the infantry to
move across a dry section of the canal just 2,600 yards wide, and then fan out over
a wide front towards the north east.

Infantry passing over the St Quentin Canal at Riqueval, 2 October 1918.
On 29 September, the 1/6th North Staffordshire Regiment of the 46th (North Midland) Division captured the bridge here before the Germans could explode demolition charges. Hidden by thick fog on the morning of the attack, many of their preparations were covered. By nightfall they had captured part of the main Hindenburg Line and its Support Position, penetrating more than three miles deep.

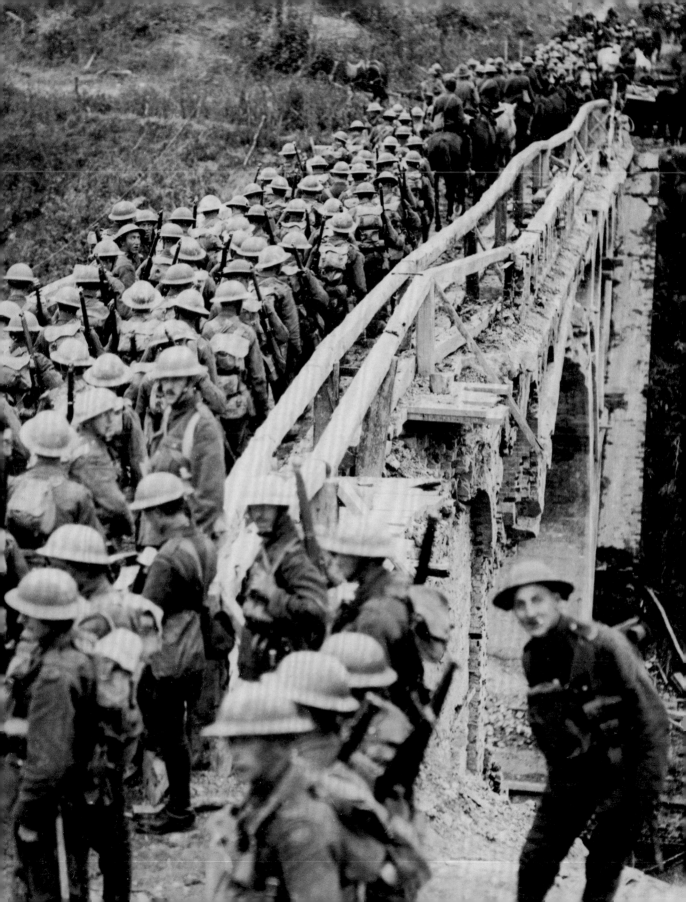

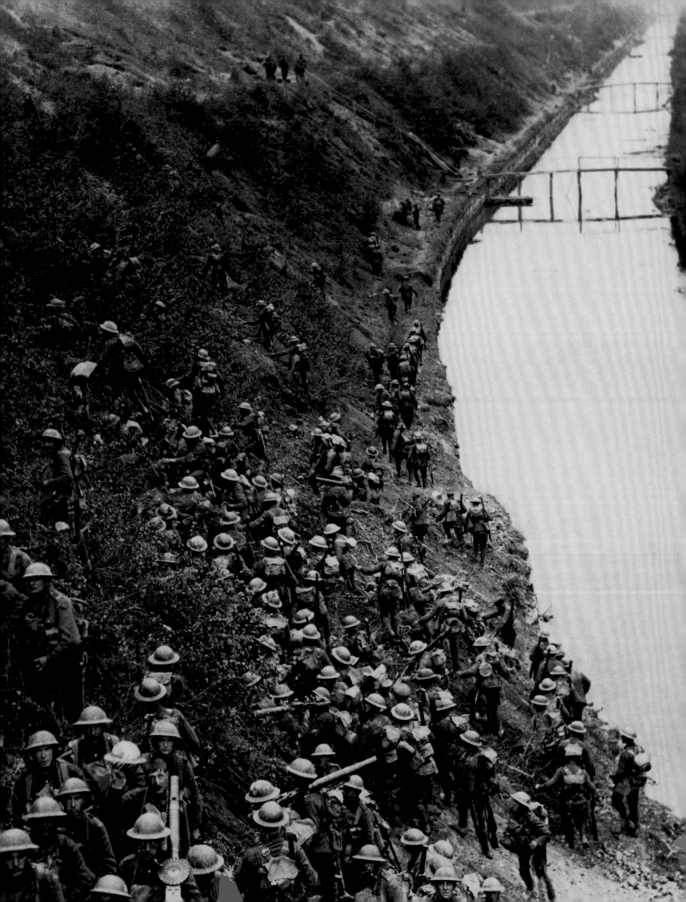

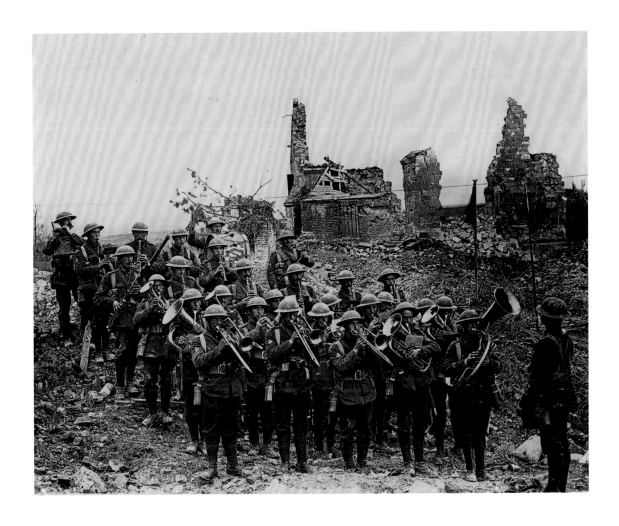

◄ Part of the St Quentin Canal showing the infantry massing on the east bank after crossing the bridge at Riqueval, 2 October 1918. It is clear from the width of the canal that tanks would have been useless here: just one site on the St Quentin Canal, at Bellicourt, ran underground through a tunnel, and it was here that the tanks were to cross.

▲ The band of the 137th (Staffordshire) Brigade playing amid the ruins of Bellenglise after crossing the St Quentin Canal. Convinced that American and Australian forces further north would carry out the main assault, many feared that rushing the defences of Bellenglise would be nothing more than an unnecessary sacrifice. However, screened by a creeping barrage, the attackers accomplished something that few of their officers thought possible.

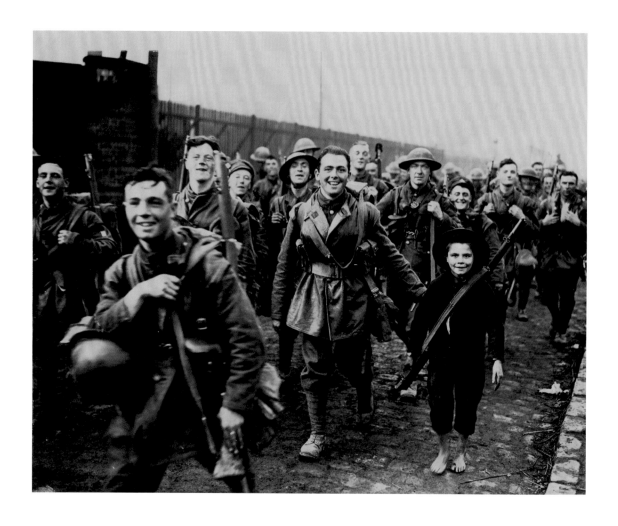

Troops of the 57th Division of the 8th Battalion, the King's (Liverpool)
Regiment, otherwise known as the Liverpool Irish, entering Lille,
18 October 1918. The barefooted French boy has been given a rifle and a helmet
by the smiling soldier on his right. The Germans had abandoned the city one day
earlier with morale plummeting amongst the men: an army censor noted that 'the
majority of letter writers … now vehemently demand peace at any price'.

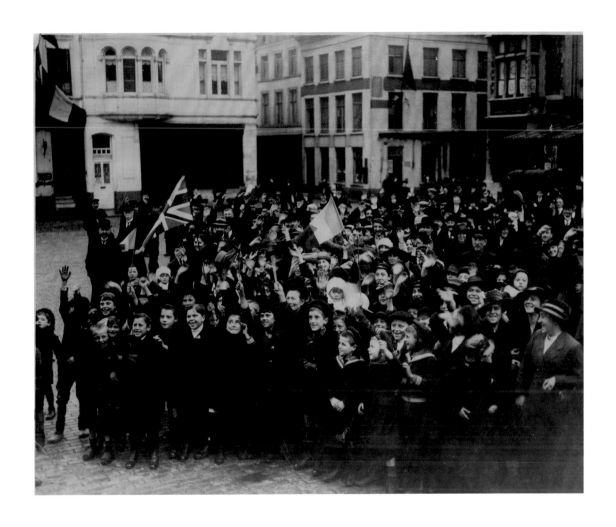

The first photograph taken after the recapture of Ostend, 20 October 1918.
Throughout mid October, the Allies liberated large areas of western Belgium –
a rapid thaw after the frozen trench warfare of the previous four years. The day
after this photograph was taken, the German cabinet agreed to President Wilson's
demand for the evacuation of occupied territory but avoided the issue that the
US were attempting to put on the table: the abdication of the Kaiser and the
establishment of 'representative government'. It was not for another fortnight that
an armistice 'at any price' would be accepted.

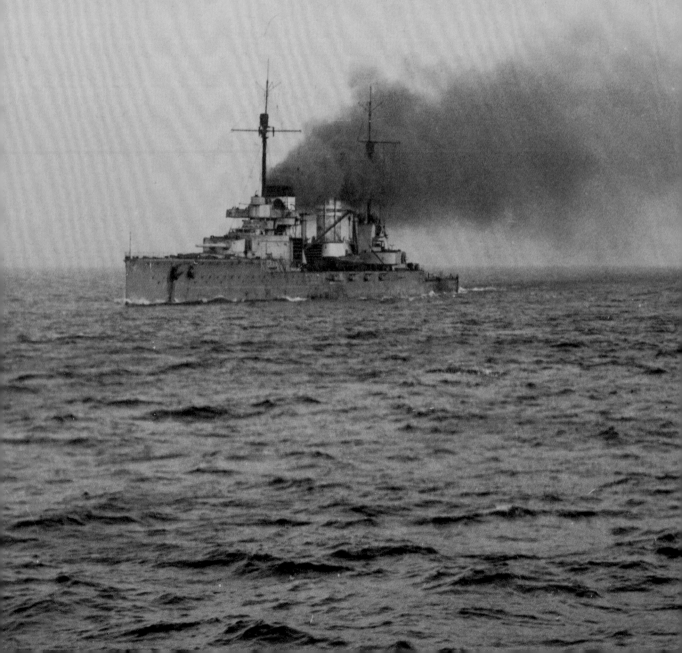

SURRENDER AT SEA

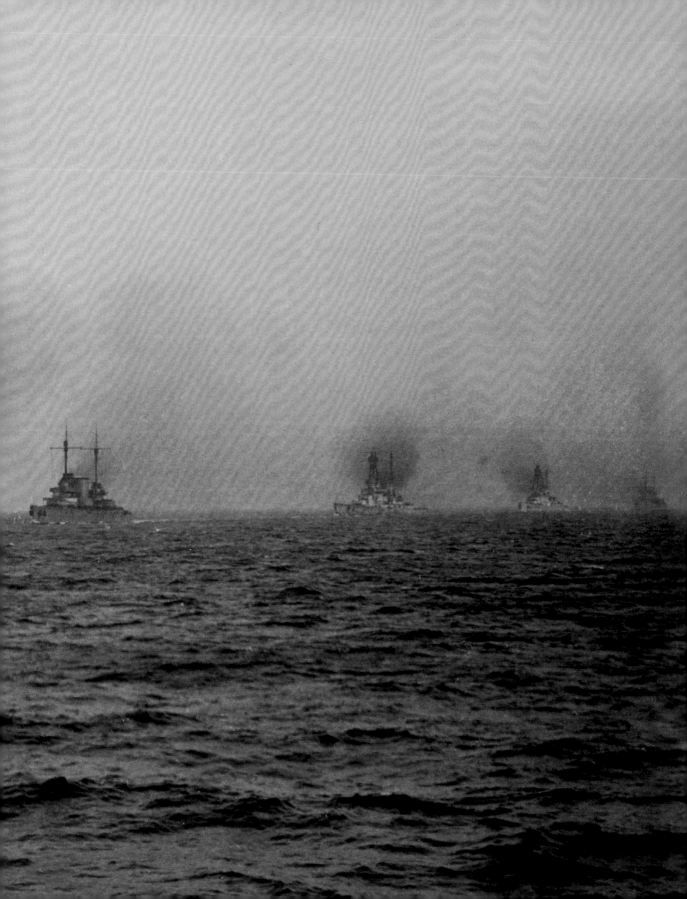

The German Admiralty was well aware that the withdrawal of Ludendorff's army during the Hundred Days Offensive meant an end to the land war. However, unlike the army, the Imperial German Navy remained essentially undefeated, the only fleet engagement of the war having taken place in 1916 off Jutland Bank – the inconclusive result notable for being the last action in the great Nelsonian tradition of two ranks of opposing line-of-battle ships. Since that time, the army and navy had, to all intents and purposes, fought separate wars. If the German admirals had coordinated activities with their counterparts on land, it might have been possible for them to disrupt the flow of reinforcements and material from Britain to France in the immediate aftermath of Operation Michael. Instead, chafing in port as the British proceeded to blockade their routes into the North Sea, the admirals watched in horror as the Kaiser's army slowly bled to death. There was to be one last roll of the dice.

On 29 October the German High Seas Fleet was ordered to sea for the final time to preserve its honour. The demand from President Wilson, that Germany suspend all U-boat operations prior to any armistice, was to be circumvented by provoking a decisive battle with the British Grand Fleet in the North Sea. This drew echoes of the Dutch raid on Medway in 1667 – a pre-emptive strike in the Second Anglo-Dutch War that embarrassed Charles II and strengthened the hand of the Dutch in subsequent peace negotiations. Far from being a madcap manoeuvre, it was a carefully-balanced risk by the German Admiralty that sought to achieve something Ludendorff had not: namely, to cause a last-minute panic amongst the Allies as they stood on the cusp of victory.

The German Admiralty had reckoned without the morale of their ratings. When the order to

sail was given, sailors in port at Wilhelmshaven broke into mutiny. Efforts to put down the uprising resulted in the insurgents breaking into the armouries, seizing weapons and taking to the streets; Admiral Hipper was forced to abandon the entire operation with unrest simmering through the fleet. In less than a week, the Baltic port of Kiel was in the hands of revolutionists, and the Kaiser's brother, Prince Henry of Prussia, had to flee the city in disguise. The Kiel mutiny was the starting point of the November Revolution and led to the proclamation of the Weimar Republic. Chaos broke out in other parts of Germany. Far to the south, a crushing Italian victory at Vittorio Veneto drove the Austro-Hungarians from the war and laid bare the German southern flank. The gamble had failed. In a railway carriage at Compiègne, the armistice was signed just after 5 a.m. on 11 November.

The Kaiser had earlier demanded the High Seas Fleet be preserved as a negotiating tool for any peace conference, but the European Allies were adamant it should not survive. Article XXII of the armistice provided for the surrender of the German submarine fleet, although there remained deep disagreement amongst the victors as to what should happen to the capital ships. The British and French Admiralties wanted them to be surrendered, believing that the terms should have the same effect on German naval strength as a defeat in a full-scale battle, whereas Wilson and the Americans – all too conscious of the post-war balance of power – argued they should be interned in a neutral port. Initially the politicians overruled the admirals: Article XXIII stated that a total of seventy-four ships (ten battleships, six battlecruisers, eight light cruisers and fifty of the most modern destroyers) should be interned. However, it became apparent that preventing sabotage

or a dash for freedom from a neutral location would be almost impossible without infringing local sovereignty. Eventually the British steered the plans towards the High Seas Fleet being interned in their anchorage at Scapa Flow. As an addendum to the text of the agreement, the Allies informed the German delegation that they would seize Heligoland if the ships to be interned were not ready to sail on 18 November.

The entire process was to be one of utter humiliation. On 12 November Admiral Beatty summoned German Rear-Admiral Meurer to his flagship, the *Queen Elizabeth*, to dictate arrangements for the internment. Meurer was handed papers detailing the procedure for the transfer of ships and was read the conditions for the forfeiting of the U-boats. The fleet was to be shamed: the letters 'S.M.' (*Seiner Majestät*; 'His Majesty's') were ordered to be torn from the sailors' cap-bands so that just the name of the ship remained, and the Imperial tricolour on their caps was to be painted red. Officers had to remove their badges of rank. Eventually, at noon on 18 November, Rear-Admiral Ludwig Van Reuter took command of a German fleet that was descending into squalor as officers lost control of their men,

and over the next 36 hours, his ships straggled out into the North Sea.

What the Germans called the 'endless mourning procession' was now underway. As they moved through the Heligoland Bight in line astern formation, the destroyer *V30* strayed off course, hit a mine and sank. (Beatty, relentless in his efforts to fulfil the terms of the armistice, demanded a replacement vessel be surrendered to restore numbers.) The British bombarded the Germans with radio signals, fearing even at this late stage that treachery was afoot, but in the pre-dawn haze of 21 November the British light cruiser *Cardiff* led the pride of the Imperial Navy to a massive Allied flotilla consisting of 370 British, American and French warships. Operation Z2, which divided the Allied ships into 'Red Fleet' and 'Blue Fleet' for escort purposes whilst airships and aircraft circled overhead, was a staggering welcome – the largest gathering of sea power in the history of the world. Later on the 21st, Beatty signalled the German ships in the Firth of Forth:

The German flag will be hauled down at 3.57 in the afternoon [i.e., at sunset] and is not to be rehoisted without permission.

PREVIOUS PAGE

The German fleet steaming towards surrender, 21 November 1918. From the mid 1890s, Germany had used her industrial and economic strength to build up the Imperial German Navy, and the early years of the new century saw a concerted arms race as she sought to outdo Britain in capital ships. The German fleet, vessel for vessel the most modern navy in the world, was the product of a Prussian geo-political obsession that helped push the world into war.

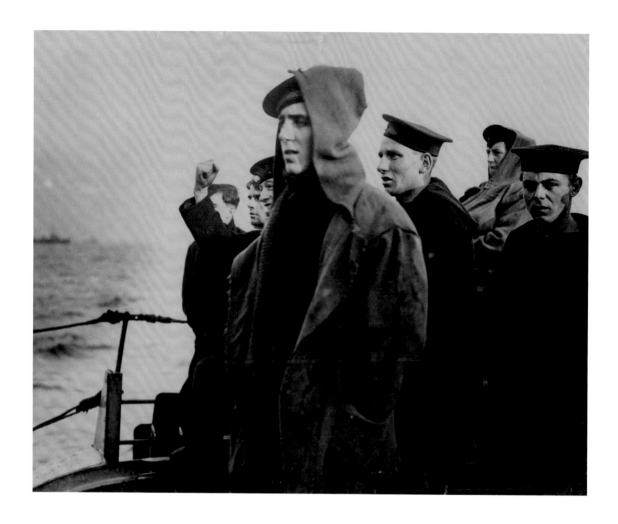

Waiting for the German fleet to come out, 21 November 1918. By the last year of the war, the Allies had numerical advantage in the Aegean, the Adriatic and the North Sea, and controlled all the global sea lanes except those in the Black Sea and the Baltic. Despite this, there was much unease in London: Admiral Beatty continued to believe that, broadside for broadside, his margin of superiority was so thin that containment was the best strategy. From 1916 onwards, bottling up the German 'dreadnoughts' – rather than forcing a Trafalgar-like engagement – formed a crucial part of the Allied approach.

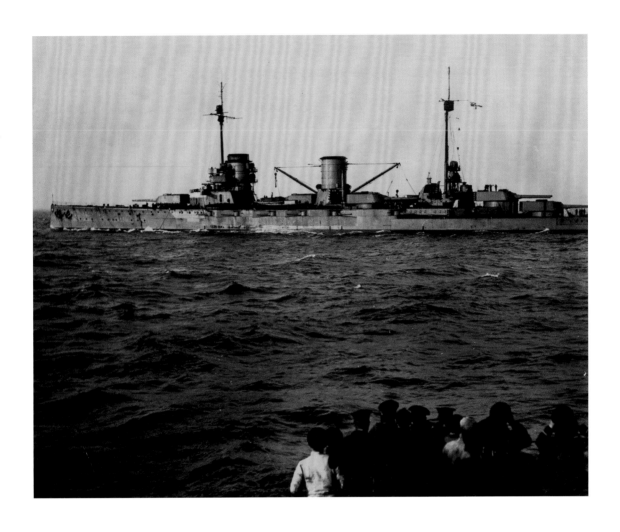

The *Moltke*, one of five German battle-cruisers which led the surrender line. Her ten 11-inch guns are trained fore and aft, according to Beatty's instructions. The Kaiser had built Germany's High Seas Fleet as much to apply political leverage to Britain as to physically destroy the Royal Navy, and as his army disintegrated during September and October he demanded it be preserved for any potential peace conference. The European Allies were equally clear that would not happen.

British crew at Harwich watching the Germans U-boats surrender.
The decision to pursue unlimited submarine warfare edged the Americans closer
to entering the war in 1917, a critical factor in the balance of power in 1918. Article
XXII of the armistice provided for the full surrender of the German submarine
fleet. After sailing on 21 November, a first consignment of twenty U-boats were
met off the coast of Essex by a small flotilla of British warships commanded by
Rear Admiral Sir Reginald Tyrwhitt, and escorted to the Port of Harwich.

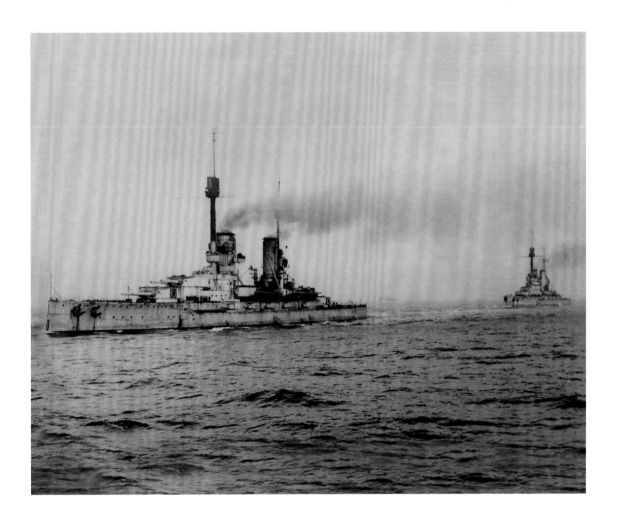

The *Kronprinz Wilhelm*, one of four *König*-class battleships in the German Imperial Navy. Launched in February 1914, she carried ten 12-inch guns in five twin turrets and was named for Crown Prince Wilhelm, the eldest son of the Kaiser. The *Kronprinz Wilhelm* was 175 m (575 ft) in length and displaced more than 28,000 tons at full load.

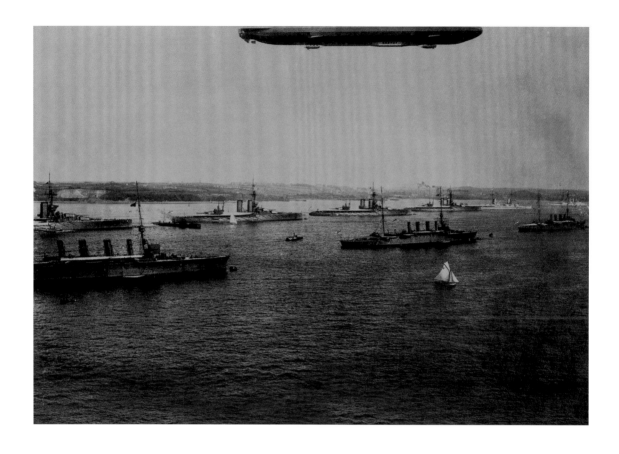

The Allied flotilla, waiting to escort the German fleet to Scapa Flow.
The two lines of ships employed in Operation Z2, 'Red Fleet' and 'Blue Fleet',
can be clearly seen.

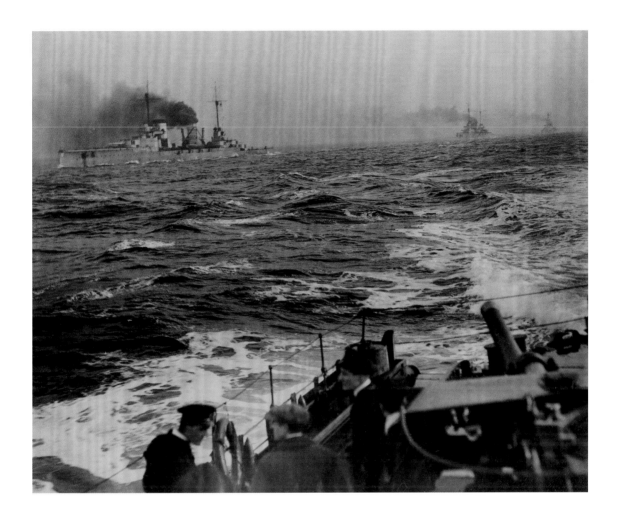

Watching the High Seas Fleet: gunnery control officers kept their reflector sights trained on the capital ships at close range as they sailed slowly through the North Sea. Once the ships were interned at Scapa Flow, their guns were disabled through the removal of their breechblocks, and their crews were reduced to 200 officers and enlisted men on each of the capital ships.

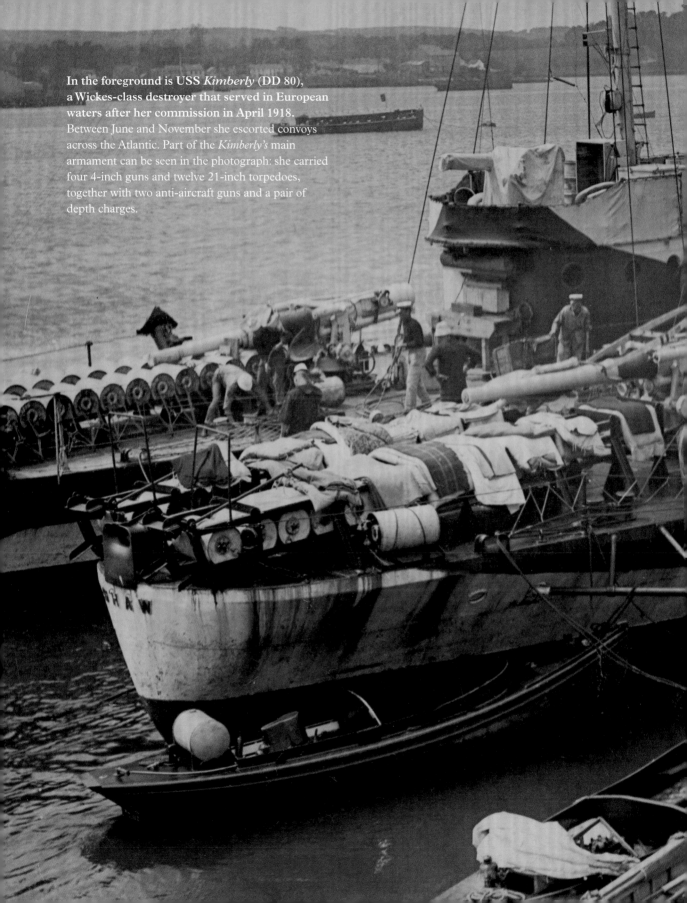

In the foreground is USS *Kimberly* (DD 80), a Wickes-class destroyer that served in European waters after her commission in April 1918. Between June and November she escorted convoys across the Atlantic. Part of the *Kimberly's* main armament can be seen in the photograph: she carried four 4-inch guns and twelve 21-inch torpedoes, together with two anti-aircraft guns and a pair of depth charges.

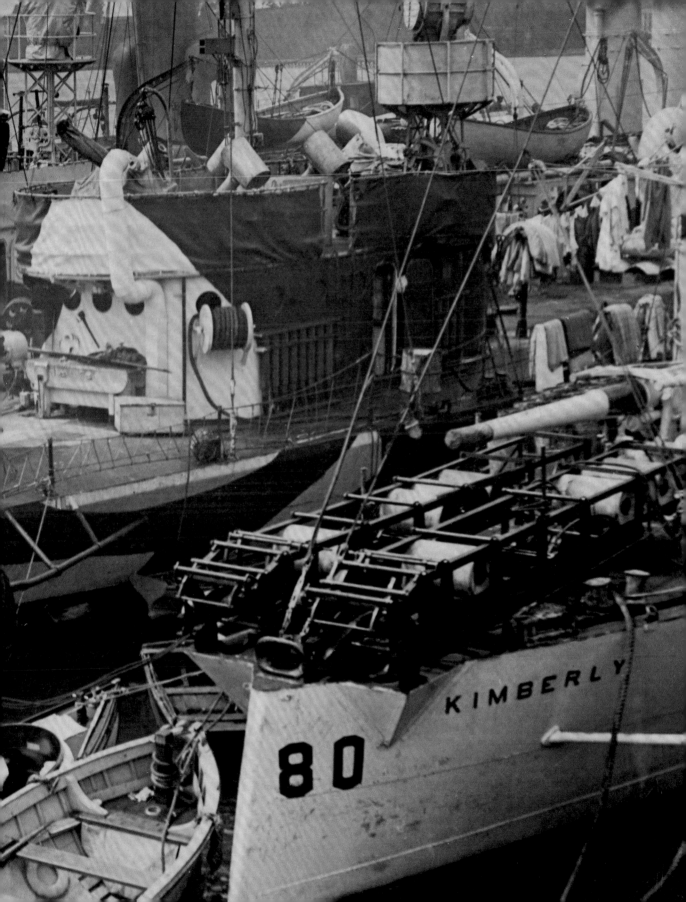

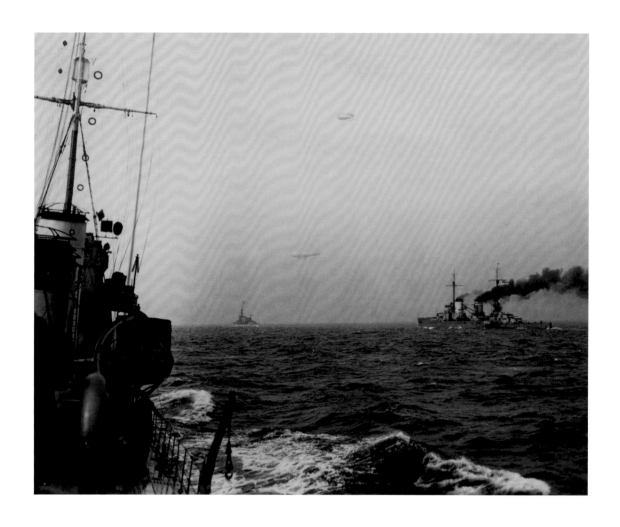

The victors were leaving nothing to chance: airships can be seen high above the German Fleet. The fleet remained in captivity during the negotiations that ultimately produced the Treaty of Versailles. Rear-Admiral Van Reuter believed that the British intended to seize the German ships on 21 June 1919, which was the deadline for Germany to have signed the peace treaty. In protest at the severity of the terms, Reuter ordered the ships to be scuttled. Only one battleship, *Baden*, three light cruisers, and eighteen destroyers were saved from sinking by British harbour personnel.

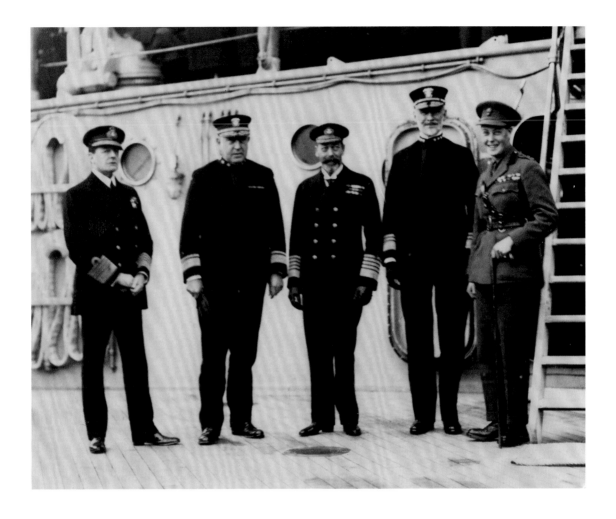

The King aboard the *Queen Elizabeth* inspecting the British Grand Fleet, with the Prince of Wales, Admiral David Beatty, and Admiral Rodman and Admiral William Sims of the US Navy. Sims was Commander of US Naval Forces in Europe; Rodman was Commander of Division Nine (which served as the Sixth Battle Squadron of the British Grand Fleet) and was present for the surrender of the German ships.

A German U-boat at Westminster Bridge, 5 December 1918. After being removed to Harwich, the Admiralty decided that surrendered German submarines were to be taken around various British ports and seaside resorts for public display following the end of the war. An admission charge was levied for those who wished to go on board.

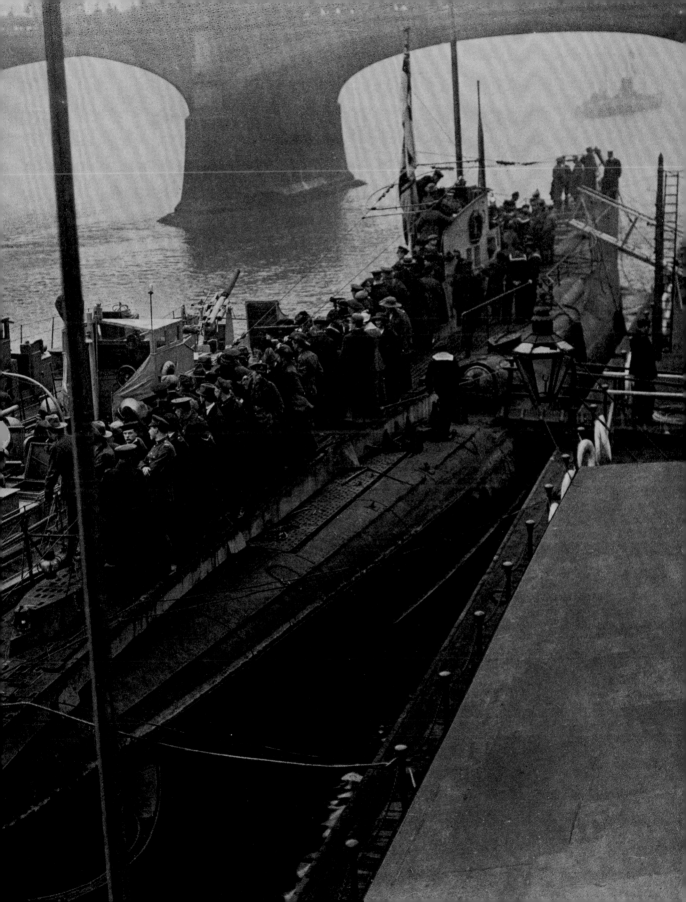




- CHAPTER SEVEN
- VICTORY... AND THE FALLEN

There are signs in the crowd reading "ROYAL AIR FORCE HOW TO JOIN THE ROYAL AIR FORCE"





✈ CHAPTER SEVEN ✈

VICTORY ... AND THE FALLEN

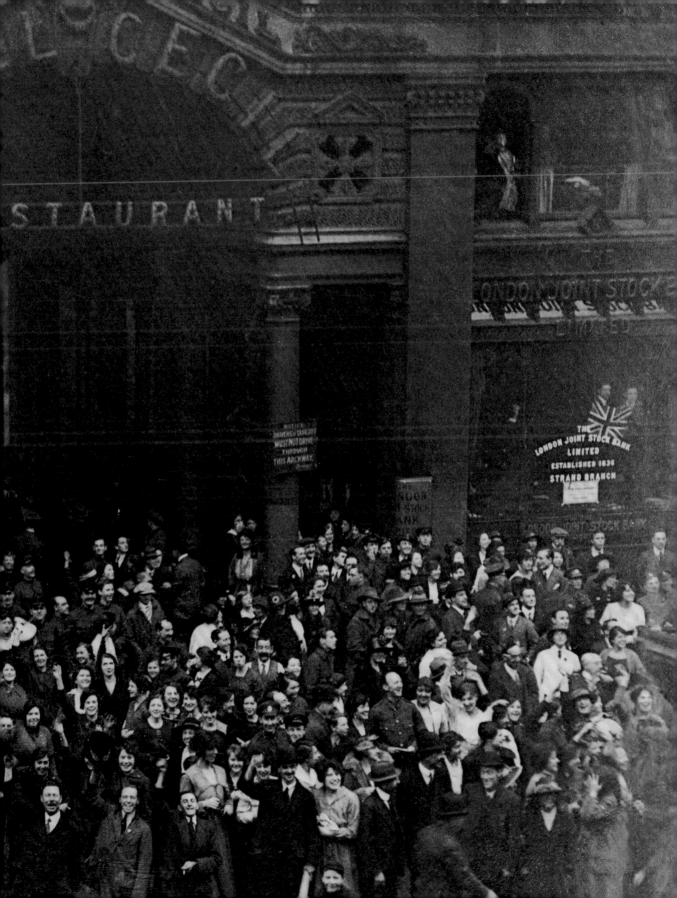

The guns continued firing until the final moments. Marshal Foch issued a General Order to the armies in the early morning: 'Hostilities will cease on the whole front beginning 11 November at 11 o'clock French time. The Allied troops will not, until further orders, go beyond the line reached on that date and at that hour.' Troops were ordered to unfix bayonets, unload magazines and await further orders. At Westminster, Lloyd George read the armistice terms to a cheering House of Commons. Paris was a riot of colour as men, women and children flooded into the streets. On London's Oxford Street, buses and lorries were festooned with flags and swamped by cheering figures. Hoardings that had protected statues from bombing were torn down. In Cambridge, as elsewhere, effigies of the Kaiser were burned, and in the industrial north, general holidays were declared in mills and factories.

The rapturous public reactions in London and Paris came as a stark contrast to the muted reception in the trenches – and for that matter, amongst the senior politicians. The very nature of the First World War prevented unalloyed celebration. There had been no Agincourt, no Quebec, no Trafalgar; rather, victory had been achieved by the invisible forces of economic muscle, unglamorous naval blockades, grinding attrition and the enemy's self-inflicted decline. True, Germany had been wholly defeated on the battlefield; true, the technological advances in arms and armour had enabled a swifter end to the war than many expected. But for the victors, once the initial euphoria wore off there remained only exhaustion, whilst for the vanquished there lurked a dark foreboding about the future. To compound matters, an influenza pandemic was sweeping the globe, killing 7,000 a week in Britain by October 1918 and perhaps 30 million worldwide.

Most troubling was the lack of a definitive ending to the conflict. Germany was defeated but not destroyed, overcome but not occupied, her self-proclaimed martyrdom destined to haunt Europe like a spectre. Within months the 'stab in the back' notion would emerge amongst many Germans who found it impossible to swallow defeat when victory had seemed so close. Socialists and Bolsheviks, Jews and Slavs were surely to blame for the Fatherland betraying an army still fighting on foreign soil. There remains a hideous credibility to the view that says the war of 1914-18 never really finished, that the 1920s and 1930s were merely a hiatus in a conflict that resumed with greater ferocity in 1939. Truly the seeds of the Second World War were sown, like dragons' teeth, by the First.

Furthermore, it was victory at a searing cost. Four empires – Germany, Austro-Hungary, Russia and Turkey – had collapsed into a froth of conflicting nationalities and ethnic groups jockeying for position. Large swathes of territory had been obliterated, with towns, villages and farmland reduced to wreckage. And in the shadows stood the legions of dead, many scarcely out of their boyhood, pushed beyond that which was emotionally bearable and fallen before what Sassoon called 'the monstrous anger of the guns'. In this sense, there was no triumph save an eerie silence. From the arid heat of the Arabian Desert to the sodden abattoir of Passchendaele, from the mists of Jutland Bank to the high mountains of the Caucasus, what left such awkwardness amongst survivors was the incomprehensible slaughter and the loss of achingly young lives, the wasted potential and the unrequited love, that had been endemic to those brutal years. Innocence and romance were dead.

Many who returned could never articulate their experiences. They were destined to carry the memories of the living hell they had endured for

the rest of their days. As Vera Brittain described in her memoir, *Testament of Youth* (1933), the war erected a 'barrier of indescribable experience between men and the women they loved'. For those who lived, nothing could ever be the same again. There also remained an undeniable gulf between the wartime experiences of men and women, even between the nurses who worked with the wounded and the men for whom they cared. Many women felt as if they entered society more fully due to new employment opportunities; men, by contrast, went out of society – to kill or be killed. There is very little information available to assess how ordinary families, wives, mothers, children, who had seen nothing of their men for years, watched them adjust to normal life when they returned home. Even less tells us how families coped on a reduced income due to disability, or about the psychological trauma of what the men had seen – nightmares peopled in their waking and dreaming memories by their fallen comrades.

For too many, there was no homecoming. Entombed in crumbling shell holes, drowned in submerged trenches or blown before the wind by machine gun fire, their bodies simply returned to earth. 9% of all British men aged between 20 and 45 were killed, and 17% of all French soldiers: it was felt that the generation that remained had lost its sense of direction. Just as the daunting memorial at Thiepval records the names of 72,000 never found or identified on the Somme, so the precise death toll of the war as a whole can never be known. Even if it could, a mere number would remain as incomprehensible as the comradeship, sacrifice and devotion to duty that marked those terrible days. Incomprehension was the fate for the countless thousands and tens of thousands: sappers buried in collapsed tunnels, infantrymen sagging on barbed wire, pilots shot from the sky, tank commanders choking in gas clouds, naval ratings lost to the seas. The old world had passed. As one British officer, Jack Adam, wrote to his wife in March 1918: 'I am sorry your dreams cannot carry on any longer'.

It was on a battlefield of another war that a great American president declared the impossibility of hallowing the ground on which battle had been joined. It is those who died, Abraham Lincoln avowed, those who have passed beyond the sight of men, who hallow it. It is they who in memory live on.

The evening brings all home

RECEIVED FROM E.L (Eiffel Tower) **G. H. Q.**
STATION Wireless Press Date 11th Nov 1918
BY J. Mankin Time 7.30 AM

Maréchal Foch à
commandant en chef.

Les hostilités seront
arrêtés sur toute le front,
à partir du onze Novembre,
onze heure (heure Française.)

Les troupes Alliés ne-de-
pas-seront. pas jusq'à nouvel
ordre la ligne atteinte à cette
date et à cette heure.

Signé Maréchal Foch

(25975). Wt. 2836—M2209.- 5000 Pads. 6/17. P.C.M. & Co. (E. 1325.)

114

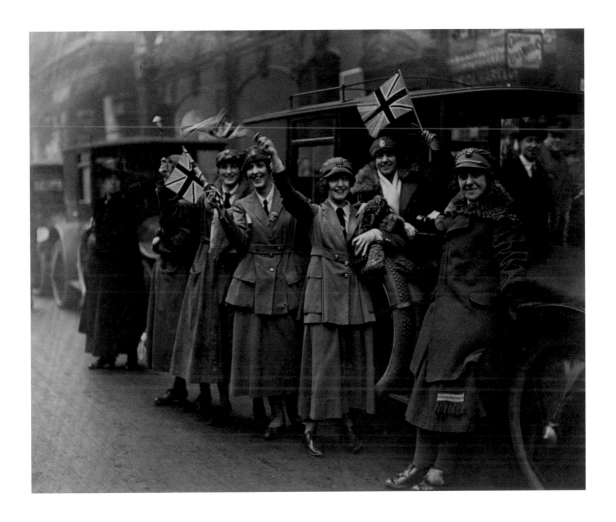

◄ **Armistice telegram from Marshal Foch announcing the cessation of hostilities at 11 a.m. on 11 November 1918.** The definitive text of the armistice was agreed overnight on 10-11 November and signed shortly after 5 a.m., leaving only six hours to telegraph the news to the front lines. Soldiers at the front fought to the last moment, and in some areas hostilities continued after 11 o'clock because it was not possible to communicate the news to the forward positions.

▲ **WRAFs gathered outside the Royal Air Force headquarters at the former Hotel Cecil, 11 November 1918.** After its formation on 1 April 1918, Hotel Cecil at 80 Strand was the RAF's first HQ. Once London's largest hotel, it was requisitioned for the war effort in 1917. A green plaque was unveiled in 2008 to mark the location.

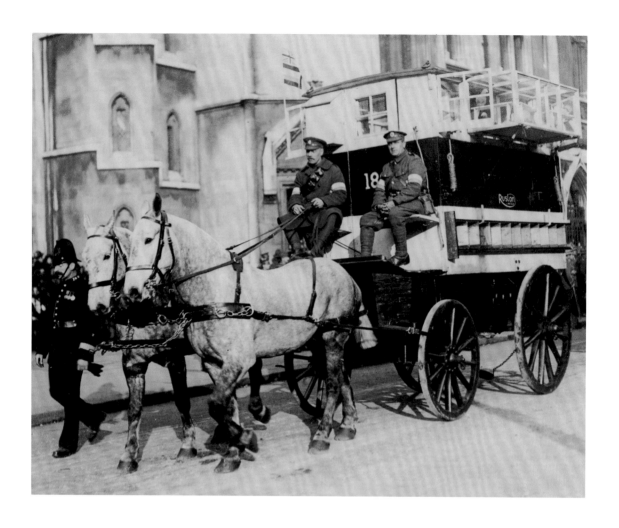

Pigeon carrier in Lord Mayor's Show, 9 November 1918. Two days before the
November armistice, the Lord Mayor's Show in London had featured captured
armaments that were paraded in front of the Royal Courts of Justice in anticipation
of what was to come. It was the very day of the Kaiser's abdication. On the same
day, captured German guns were displayed in the Place de la Concorde in Paris.

German Pfalz D.III, on display outside the Royal Courts of Justice, London, during the Lord Mayor's Show on 9 November 1918. According to the caption, the aircraft was shot down in aerial combat near Arras less than four weeks before the armistice. The fuselage bears a swastika alongside the Iron Cross. The swastika symbol was used in a variety of forms by both sides (including as an emblem for British War Savings Certificates and on the shoulder patches of certain American troops); only after Hitler's rise to power did it become inextricably tied to Nazism.

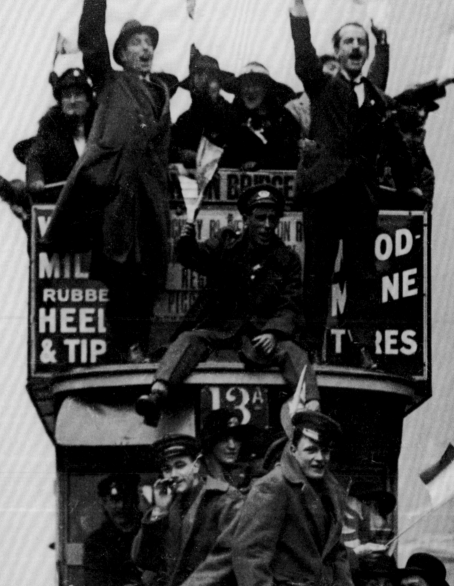

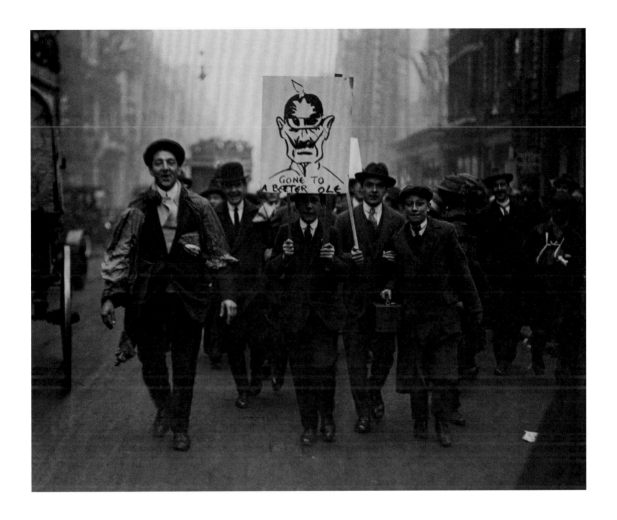

◄ An overcrowded London bus on victory day, 11 November 1918. Such scenes were repeated in towns throughout Britain and France. Elise Bidet wrote of Paris: 'I have never seen so many flags and they are all in the colour of the Allies. The view is magnificent.'

▲ Rejoicing crowds in London, with a caricature of Kaiser Wilhelm II, 11 November 1918. The Kaiser's abdication brought with it the collapse of the Hohenzollern monarchy, and the end of the German Empire founded by Bismarck in 1871.

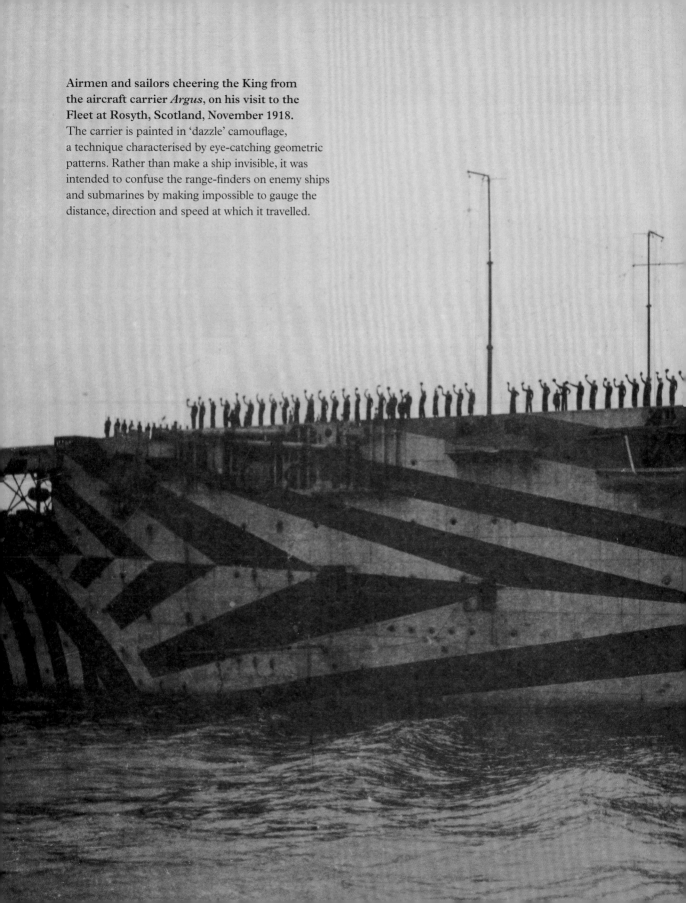

Airmen and sailors cheering the King from
the aircraft carrier *Argus*, on his visit to the
Fleet at Rosyth, Scotland, November 1918.
The carrier is painted in 'dazzle' camouflage,
a technique characterised by eye-catching geometric
patterns. Rather than make a ship invisible, it was
intended to confuse the range-finders on enemy ships
and submarines by making impossible to gauge the
distance, direction and speed at which it travelled.

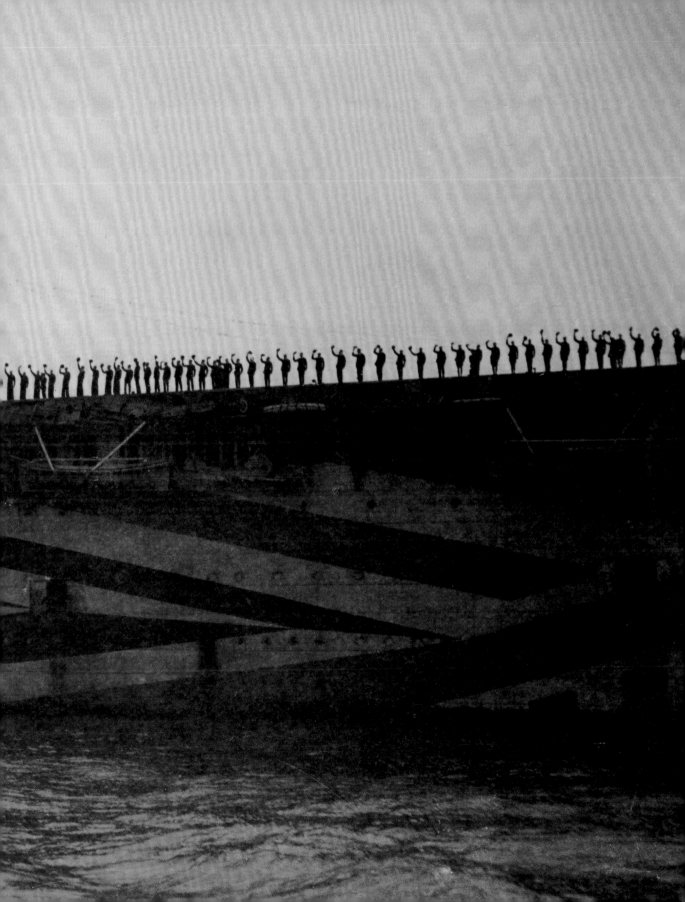

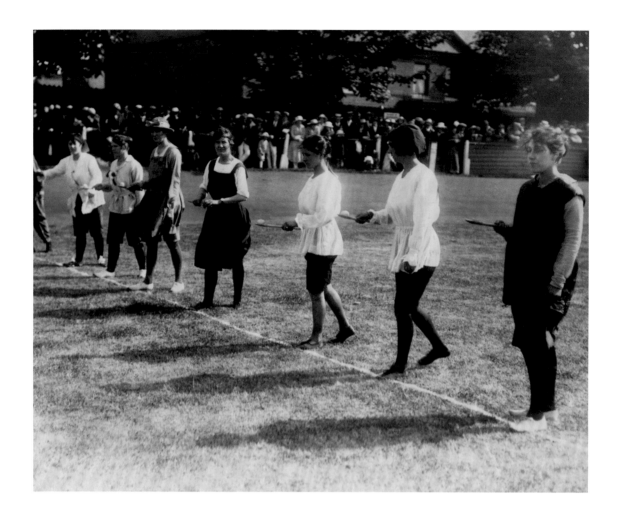

Women from the Chilwell National Shell Filling Factory, Nottinghamshire, at a sports day event in 1918. Competing women wore working clothes, consisting of white or khaki blouses and divided skirts, whilst the officers' 100-yard flat race was conducted in full dress uniform. During the war, the factory held a number of sports activities for its workers including men's and women's football matches and a women's tug-of-war competition.

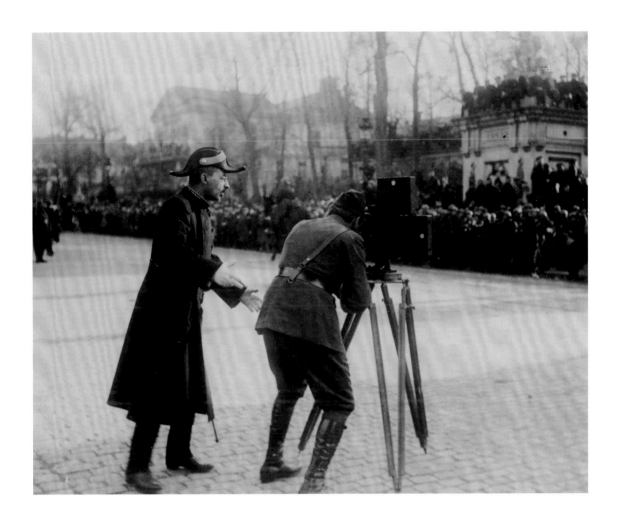

Rue de la Loi, Brussels, 22 November 1918. A cameraman from the British
army photographing the general exuberance on the streets of the capital. During
1918, Hindenburg had called for years of military occupation of Belgium to
protect the industrial Ruhr, as well as control of Belgian railways so Germany
could invade France quickly in any subsequent war. The terms of the armistice
insisted German troops return behind their own border.

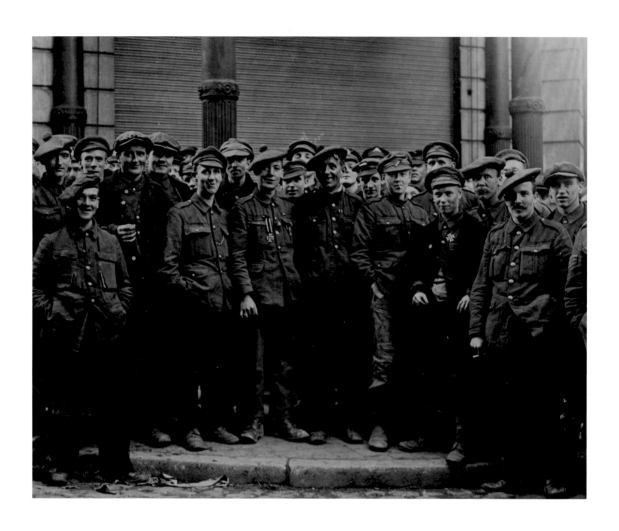

**The first liberated British prisoners of war in Tournai, France,
14 November 1918.** Two of the soldiers at the front have Iron Crosses as souvenirs.
Immediate repatriation of all Allied prisoners and interned civilians was included
in the armistice terms, although German captives languished in British and French
captivity until after the signature of the Treaty of Versailles.

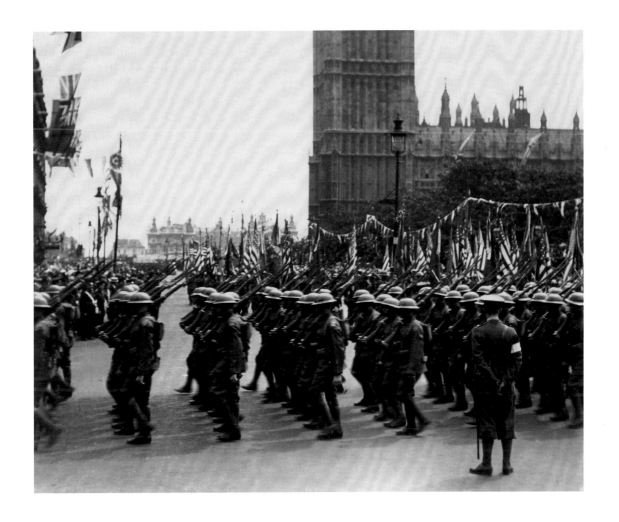

American troops marching past the Houses of Parliament, 1918.
The Americans were woefully underprepared for the massive continental war
to which President Wilson committed them in 1917. Both the French and the
British made less-than-subtle requests that the green American troops be trained
in Europe and amalgamated into existing armies; General John J. Pershing,
commander of the American Expeditionary Force, remarked that he 'was decidedly
against our becoming a recruiting agency for the French or British'. During the
Hundred Days, the Americans proved themselves to be equals in the field.

Homecoming American 'doughboys' and officers with children in arms.
There is a marked contrast with the symbolism of the following photograph.

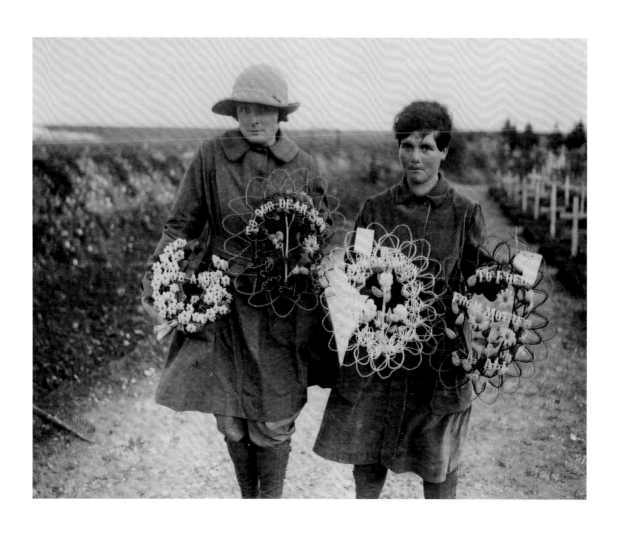

Two WAACs lay wreaths at the British cemetery, Abbeville, February 1918.
Almost 3,000 Allied war dead lie in Abbeville cemetery, not far from where the
River Somme meets the English Channel. Although the majority are British army
servicemen, troops from Australia, Canada, New Zealand, South Africa and India
are also buried there.

CHRONOLOGY

1917

11 November	Hindenburg determines that an all-out assault in the west offers Germany's best chance of success in the coming year
16 November	Georges Clemenceau becomes Prime Minister of France
20 November	First Battle of Cambrai begins
7 December	The United States declares war on Austro-Hungary
11 December	General Allenby enters Jerusalem after Ottoman retreat

1918

3 March	Treaty of Brest-Litovsk signed between Russia and the Central Powers
21 March	Operation Michael begins, the first phase of the German Spring Offensive
26 March	General (later Marshal) Foch appointed to command of Allied forces on the Western Front
1 April	Royal Air Force founded
21 April	Red Baron shot down
15 July	Final German offensive begins
17 July	Execution of the Romanov royal family in Yekaterinburg
18 July	Allied counterstroke on the Marne
8 August	Battle of Amiens begins, marking the beginning of the Hundred Days
29 September	Breaching of Hindenburg Line
30 September	Bulgaria signs armistice
1 October	Damascus taken by Arab and British forces
9 October	City of Cambrai falls to Canadian and British armies
24 October	Battle of Vittorio Veneto begins
26 October	General Ludendorff resigns
30 October	Ottomans sign armistice
3 November	Austro-Hungary signs armistice (effective 4 November)
9 November	Kaiser Wilhelm II abdicates; German republic proclaimed
11 November	5 a.m. armistice signed
	11 a.m. hostilities end on the Western Front
14 November	German U-boats interned
21 November	Surrender of the German High Seas fleet
1 December	British and US troops cross German frontier

REFERENCES

Photographs taken from the Royal Armouries archive are referenced below:
RAR.150 (various), RAR.292 (various), RAR.470 (various),
RAR.970-972 (various), RAR.987 (various)

Front cover image: Soldiers, probably from the 1st Battalion The Devonshire Regiment, on the Western Front.
Back cover image: A member of the Women's Auxiliary Army Corps tending graves with British Red Cross soldiers.
Page 2: Armistice telegram from King George V, 11 November 1918.

QUOTATIONS

Page 8: 'Kismet', by Lieutenant Richard Marriott-Watson, Royal Irish Rifles, died 24 March 1918.
Page 113: From the epitaph to Private Augustus Goodland, Royal Newfoundland Regiment, died 14 October 1918.